Prairie Skies

Prairie Skies

COURTNEY MILNE

FIFTH
HOUSE
PUBLISHERS

Cover photographs by Courtney Milne
Cover design by John Luckhurst/GDL
Color separations by TrueColor Graphics Ltd./Saskatoon

The publisher gratefully acknowledges the support received from The Canada Council, Communications Canada, and the Saskatchewan Arts Board.

Printed and bound in Canada by D.W. Friesen & Sons, Altona, MB
99 00 01 02 / 5 4 3 2

CANADIAN CATALOGUING IN PUBLICATION DATA

Milne, Courtney, 1943-

Prairie skies

ISBN 1-895618-15-0 (cloth)
1-895618-25-8 (paper)

1. Landscape photography - Prairie Provinces.
2. Prairie Provinces - Pictorial works. 3. Milne, Courtney, 1943- I. Title.

FC3234.2.M54 1993 779'.36712'092 C93-098035-2
F1060.M54 1993

FIFTH HOUSE PUBLISHERS

Contents

For two school teachers in my youth:
Frank Roy, who taught me the value of the written word and a love of nature
and
Earl Dancey, who challenged me to reach for the sky

Introduction

Welcome to this glimpse of life under the big top. The sky's the limit is an age-old expression of optimism.
But for prairie dwellers, the big blue roof, rather than setting limitations, is an invitation to reach a little higher.
We have more elbow room than perhaps anywhere else on the continent. Sky gives us a feeling of spirit
partly because of its endless expansiveness, partly because it has long been regarded as a spiritual place.
For centuries, cultures around the globe have looked to the sky as a link with the eternal—sometimes for hope,
sometimes for guidance, occasionally for a sign of reassurance. Because I feel such an affinity with the sky,
I hope these photographs help to convey some of the magic I have experienced. *Prairie Skies* is my celebration,
an anthem in honor of the glorious creations of the sky gods.

I grew up in Saskatoon, the heart of the Canadian Prairies, halfway between the wooded Canadian Shield of Ontario
and the Rocky Mountains, and equidistant from the United States border and the forests of the Far North.
That's a lot of playground, and a long way to travel before bumping into a tree or mountain, or falling off a cliff.
Wherever you go on the prairie, there is a feeling of freedom, limitless space, and room to explore. When I was
growing up, distances felt more like a challenge than a hindrance. The predominant memory of my youth, in fact,
is a feeling of independence, that I could go where I liked, when I liked, and wherever that was, I was always aware
of the overwhelming presence of the sky, with me like a loyal friend. Maybe it is that sense of companionship
that makes the prairie sky so special for me.

The sky never lets you down. It makes no demands, accepts you as you are, and usually, on the prairie,
maintains a sunny countenance. Even its cloudy moods often arrive with a day or two of warning,
and with a bit of practice, you can learn to anticipate its highs and lows. And you certainly can't ask
for a friend with more character! The following pages are a colorful testimony
to the many moods and dispositions of prairie skies.

Photographing for this book was a labor of love, with the vast majority of the images
being made long before I knew there was to be a book. I was repeatedly drawn to photograph the big roof
because it offers such an exciting palette of colors and textures, and evokes so many feelings
in its ever-changing atmosphere. My hope is that if you have prairie in your blood,
these skyscapes will bring back fond memories. And if these scenes are new to you,
may they prompt a yearning for a firsthand encounter with this great expanse.

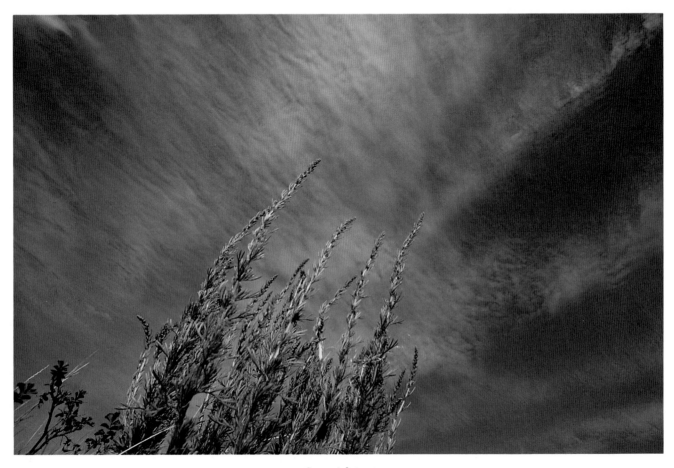

Sage Advice

———————————————

Lying on your back in summer and gazing at the midafternoon heavens is,
for me, the ultimate form of transcendence. Wispy summer clouds brushed
on a canvas of blue draw me in with hypnotic power. I like to share the space
with a sage bush or two. They spend their entire lives reaching for the prairie
sky and will point out its many features if you are open to the tutorial.

Sky as Forecast

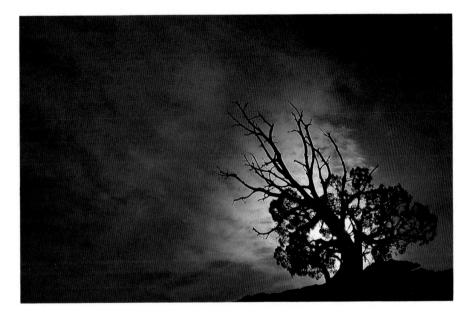

Sunbow Rhapsody

Because one can see for such enormous distances on the prairie, and because
so much of our surrounding is sky, it is occasionally possible to see tomorrow's
weather today. Sometimes it is directly visible a long way off; other times
we must learn to infer from observation. In either case, a great deal of folklore
has emerged regarding the predictive capacity of prairie skies. Let's step outside
and have a look at what prophecies are in the wind.

Sunbows (*above*) are formed when the light surrounding the sun is refracted
by a light film of cloud, usually of the cirrus variety. Because the sunbow hues
occur quite close to the sun, they almost always go unnoticed. A good pair
of polarizing sunglasses will not only darken the view, making them easier
to identify, but will also enhance the spectrum of colors. Sunbows, like
rainbows, are a prophecy of good luck and clear sailing ahead.

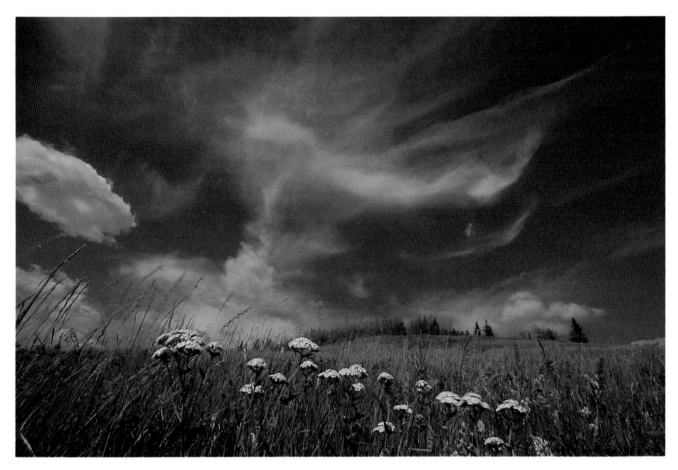

Cypress Summer

I love to romp over the high country in the Cypress Hills; it makes me feel
closer to the sky. By late June the yarrow is at its prime, anointing the
grasslands with a feathery lacework of white. At one point, you can stand so far
above the surrounding terrain that you don't need to read the sky to forecast
the weather. Just scan the northwest and watch tomorrow's cloud front
rolling in more than 100 kilometers (60 miles) away!

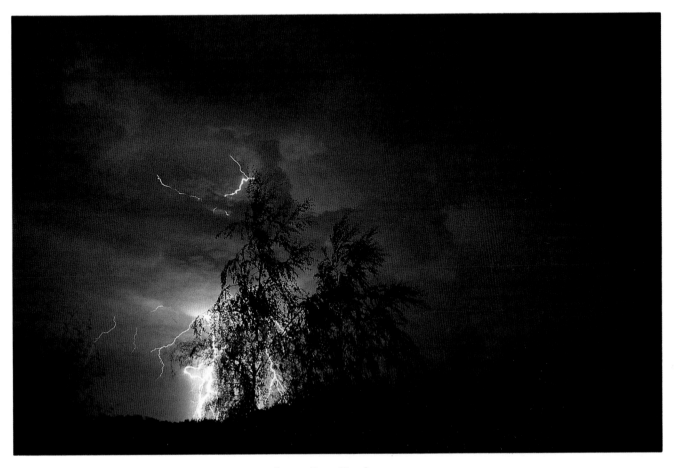

Storm Over Keechitawin

Night storms on the prairie are often dramatic, exciting, and cloaked
in an element of danger—particularly if they follow a day of intense heat.
On a clear hot August afternoon, despite the stillness of the air,
even the mosquitoes seek refuge. By evening, a bank of thunderclouds
appears from nowhere, followed by a spectacle of sound and light.
And although the lightning might perform its raindance for hours,
the ritual could pass without a single drop reaching the parched soil.

Rainbow Gold

One evening following a thunderstorm, I found gold at the end of the rainbow.
For several seconds the land was bathed in a rich sunset light.
Rainbows on the prairie can mean a number of things, but almost always
they are associated with the blessings of a good rain—
and the hope of fertility, growth, and bounty.

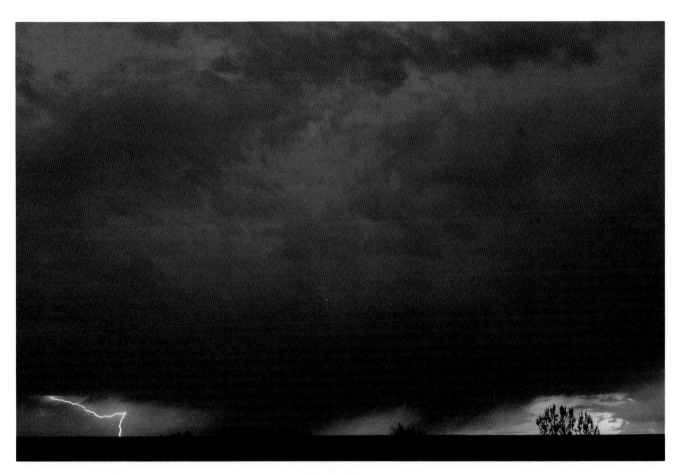

Sunset Storm

Counting the seconds of delay between a flash of lightning and the sound
of thunder can provide a good indication of how far away you are from a storm,
light being almost instantaneously visible, and sound traveling much more
slowly, about .3 kilometers/second (.2 miles/second). Add the direction and
speed of the wind, and you can often predict if and when a storm will strike.
But this brooding raincloud presented me with a puzzling question:
Was it the advent of unsettled weather, or a warm light at the end of the day?

Lone trees have always been a source of fascination to me, living out their lives
without the company of kindred spirits, bucking the relentless winds
that sweep across the plains, and giving shelter to birds and animals seeking
protection from the elements. I like to photograph them from a distance
with a wide-angle lens, which produces a scale that dwarfs the tree
in comparison with the enormity of the heavens, and symbolizes,
for me, the struggle and the defiant independence
that so characterize life on the plains.

Solitude

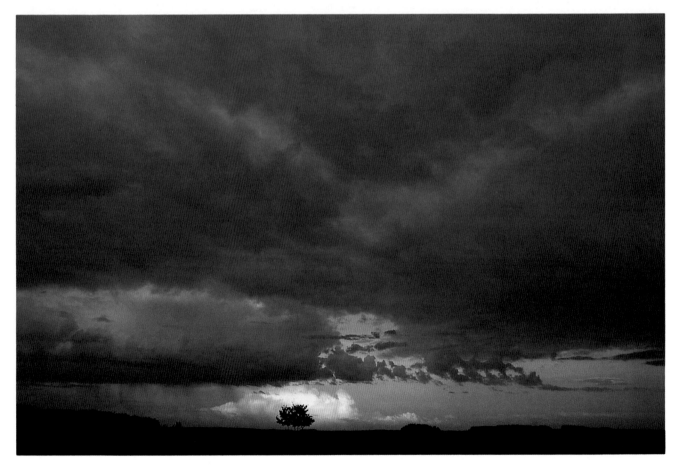

Heading for Home

Though prairie skies can extend to infinite reaches, they can also encroach
close enough to touch. Here, a storm front has crept in, the beginnings
of a cold rain illuminated by sunset light. Down below
a farmer heads for home, knowing that within minutes
the light rain could transform itself into a torrential downpour,
turning the farm trails into rivers of mud.

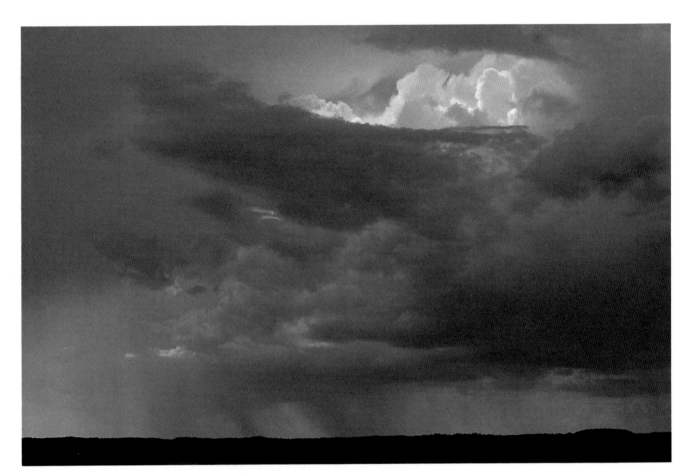

Heaven and Earth

Wide-angle lenses are basic to photographing prairie skies, to relating
one portion of the dome to another. Here I felt as if I were witnessing
two spheres of existence simultaneously. Above is a godly light
radiating through the heavens, while below the distant rain pelts the horizon.
Appreciate, I thought as I pushed the shutter; the crops badly need that rain.
When existence depends on the elements, we prairie souls
are quick to acknowledge any help from the skies.

Bugle Call

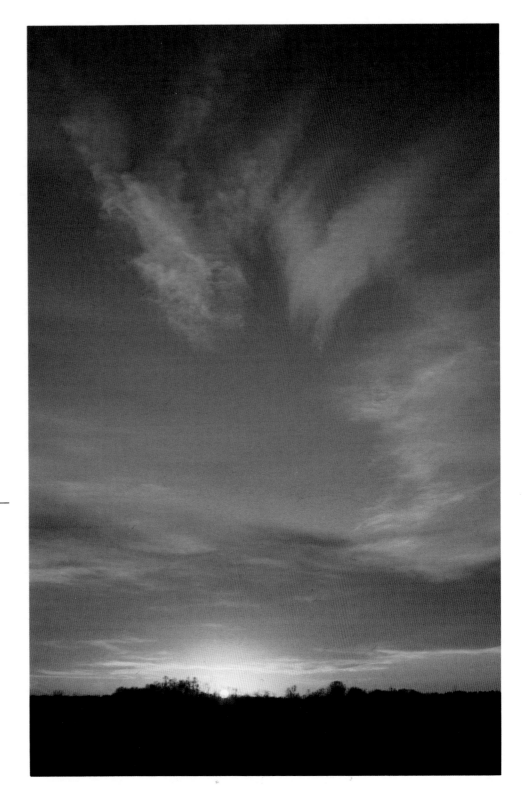

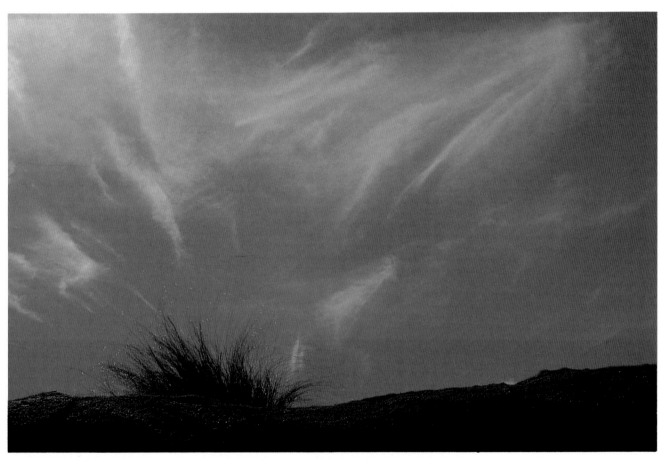

Warning

Predawn Light

Lake of the Woods

Mirages frequently occur on the prairie due to the flat land surface reflecting heat waves through which distant objects can be seen. The two most common types are lakes that quickly disappear as one approaches them, and objects that seem to grow taller when observed through the heat. Both phenomena are present in *Lake of the Woods,* where trees appear to be reflected in the surrounding pond.

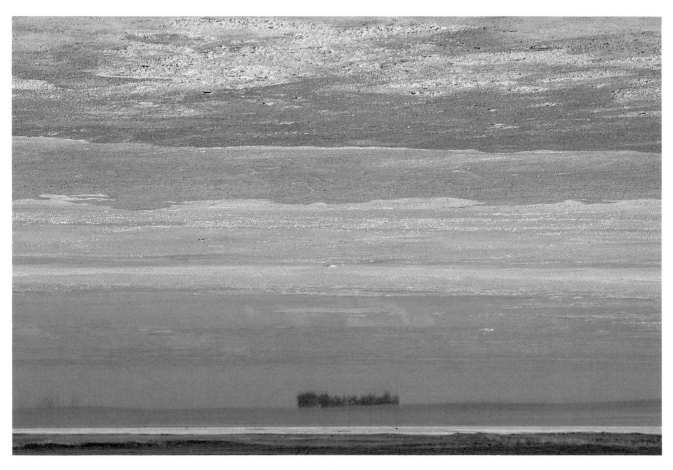

Mirage

Some prairie landscapes are so unusual that I feel I must be seeing a mirage.
In the photograph above, which is not a mirage at all, I framed
some distant trees reflected in an alkali lake, then inverted the image
for added surrealism.

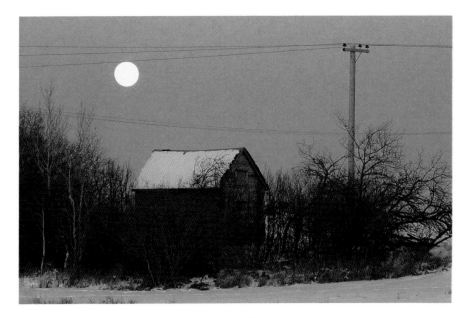

Winter Moon

This winter scene offers a perfect opportunity to appreciate the eastern sky
at sunset because the newly fallen snow harmonizes with the mauve hues
above. For 15 or 20 minutes immediately following the last glimpse of sun,
the eastern quarter acts as a giant mirror, quietly echoing the brilliance
of the postsunset light. Often we miss this magic show as we face west
and give homage to the more spectacular aspect of the sky at day's end.
But when the full moon lifts like a huge balloon suspended in a pastel sea,
it is time to bid the sun farewell and turn to greet the mysteries of the night.

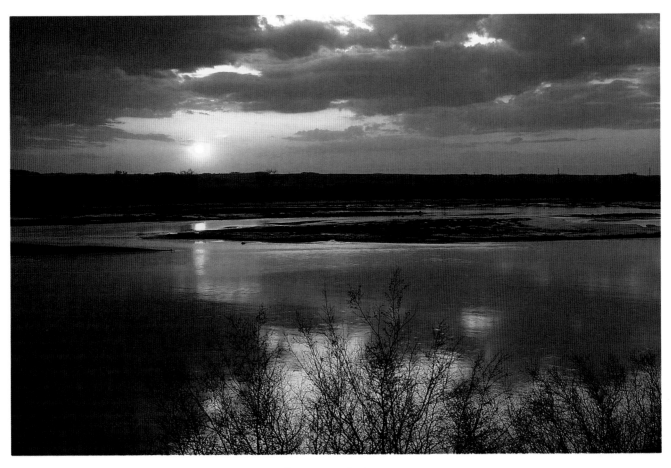

Sunset on the River

Some years ago, when I showed my prairie landscapes in Baltimore,
a young man in his late teens was overcome by the array of hues. "I don't have
any interest in photography," he confessed, "but please tell me where I can take
my motorcycle to see colors like that; our skies are always so gray. I didn't know
there could be anything so brilliant." He didn't realize it, but he was already
embarked on a spiritual search, a journey to make his personal connection
with the universe.

How often we take the clean air and vibrant colors for granted. Maybe if we too
had to make a five-thousand-kilometer (three-thousand-mile) round trip
to witness a prairie sunset, it would etch more deeply on our hearts.

15

There are no mountains in the prairie landscape, but there is nothing
to prevent us prairie dwellers from creating them in our imaginations.
The one shown here rises so high that even in midsummer, with the canola
in full bloom below, the entire mountain is white with snow! On some days,
Mount Cumulus is smothered by so much blue sky
that it disappears completely from view.

Mount Cumulus

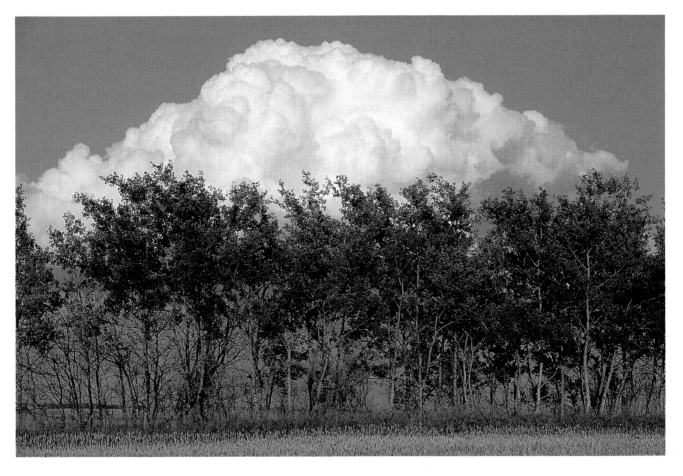

Prairie skies are always on the move. Even when there is no apparent wind at ground level, cumulus puffs drift by with amazing vitality. People who drive nonstop across the Prairies because they find it boring ought to try the trip in a convertible with the top down, and have lunch on a picnic table beneath the big blue roof. My complaint is not boredom; it is the stiff neck from watching the sky show. They shouldn't run so many episodes back to back without an intermission!

Expansion

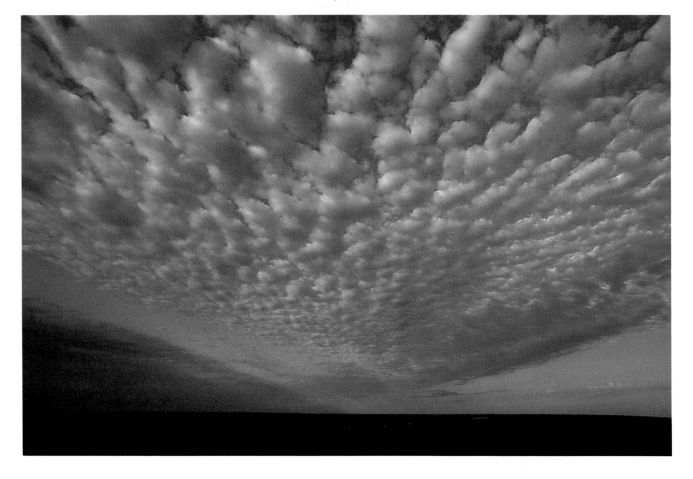

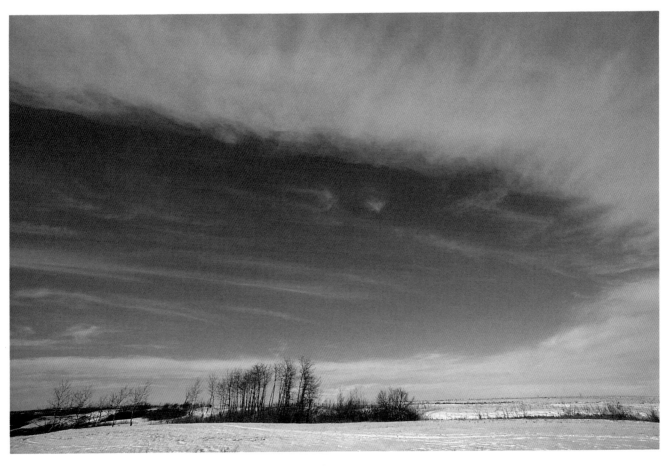

High Front

High fronts are characteristically accompanied by a clearing of the sky,
and thus are sometimes visible as they cross the heavens at an amazing pace,
providing an advance warning that we are due for a cold snap.
Time to load up the woodbox.

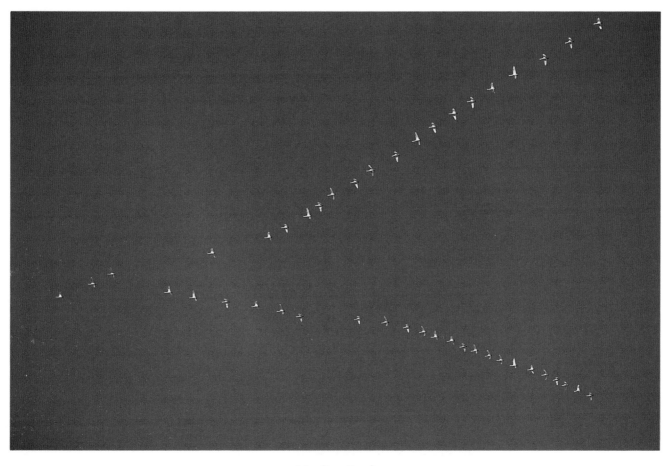

Heading South

Another forecast accompanies the great V formations of geese that grace
the autumn skies. This too is a sign of cold weather to come,
and depending when they fly, it can also be a warning
that an early winter is in store.

There are few birds that can command the attention given to geese in flight:
First the distant cackling, then a glimpse of the familiar V shape, and suddenly
their voices shatter the atmosphere with an ear-splitting cacophony
as they leave us for another year.

19

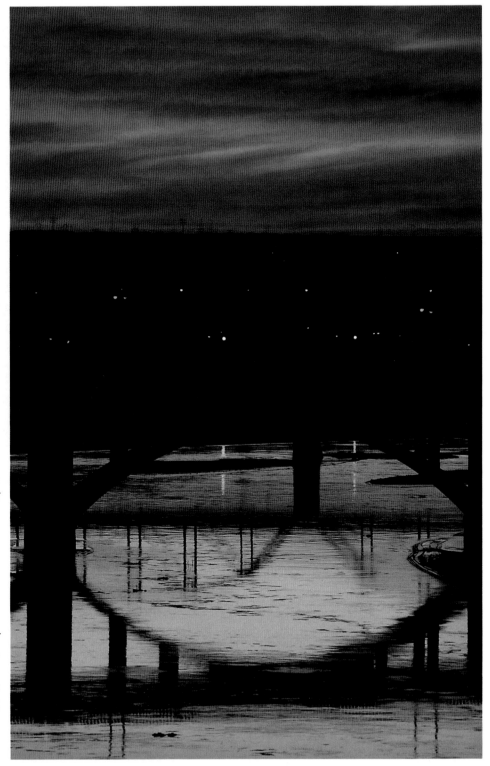

Enigmatic Light

A prairie sunset is often
enigmatic. One moment it
smiles with dazzling color and
radiant light, and seconds later
may reveal a more sinister
countenance. The lively color-
ations and warm glow can
mask the beginnings of a
brooding tempest, or as easily
dissolve into something more
demure. Experienced sky-
watchers take pride in interpre-
ting the sunset's many moods,
this subtle wisdom gleaned
from spending many evenings
in its presence and developing
a sensitivity to its shifts of
temperament, which hint at
what tomorrow will bring.

Scene from Above

Sometimes I like to photograph the sky from the top looking down, instead of from the bottom looking up. The experience provides a much different perspective, regardless of the season. Here, half the land is clothed in the white of an early snowfall, while the remainder lies naked in the somber tones of autumn. Cross-country skiers may be out while down the road, combines push on in an attempt to take off the last of the harvest.

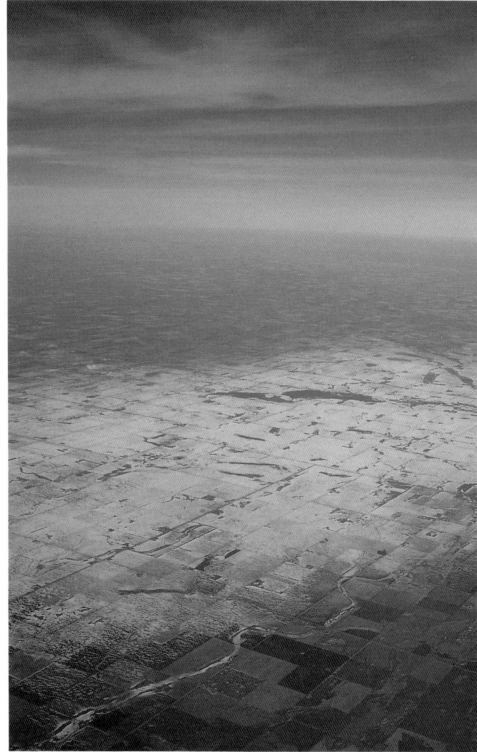

21

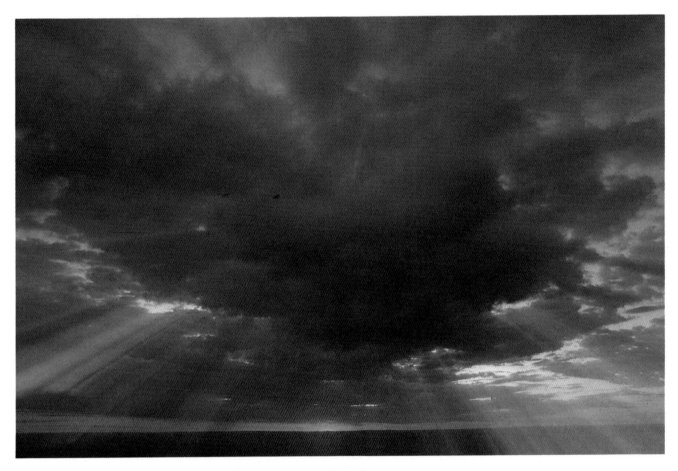

Gentle Light

Landscape photographers have to be patient. We sit for hours waiting
for just the right light, the decisive moment when all the components
of a picture come together to be documented. We bide our time until suddenly,
we have to perform. This is the popular notion and to some extent it's true,
but just as often, we tire of the wait and choose to make things happen.
Gentle Light was made because I got impatient waiting for something to change.
Focusing at infinity, I zoomed out, during a one-second exposure,
to produce the diverging rays.

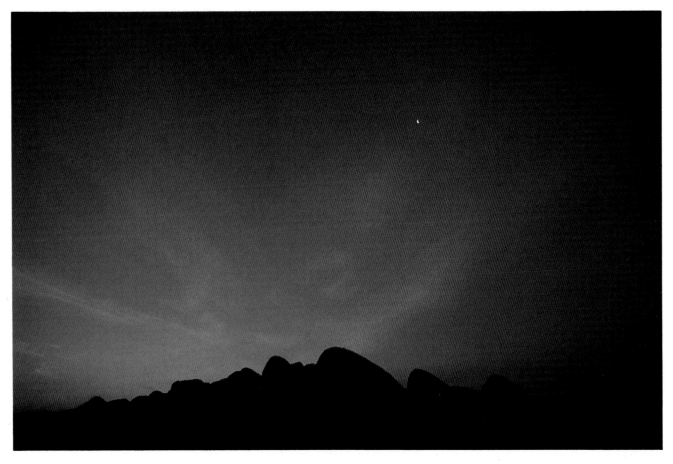

Dawn at Moose Mountain

Dawn at Moose Mountain is another example of making things happen.
Though I had a spectacular dawn sky as a starting point, I wanted to integrate it
with the Moose Mountain Medicine Wheel, which lies on the crest of a hill
in southeastern Saskatchewan. I chose a wide-angle lens, set the aperture at f22
for maximum depth of field, dropped on my belly to the lowest possible
position on the ground, and lined up the center cairn with converging lines
of cloud. The sky, then, becomes the expression of
the ancient prophecies of the wheel.

23

Autumn Canvas

Celestial Palette

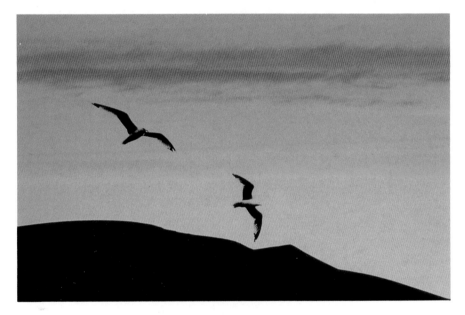

Winging It

Prairie skies are capable of every color of the rainbow, the space overhead
like a huge canvas repainted daily according to the whims of nature. Whether
it is the gray-greens of a dust storm, the fiery reds of a late summer evening,
the blues of an August afternoon, the puffy whites that drift lazily above,
or the golden light of a dawn spectacular, the heavens speak to us in graphic
tones. Sometimes in whispers, more often shouting out its proclamations,
the sky seeks our attention, demanding our admiration. And because we prairie
folk tend to keep one eye on the sky, heaven's finest masterpieces rarely go
unnoticed. Here (*opposite*) a cloudless blue expanse invites the dance of
an autumn bouquet, while a pair of gulls (*above*) seems to delight
in the lingering afterglow of dusk.

25

Sasha's Return

Twilight

Once the sun has slipped behind the hills, the western horizon can turn,
however briefly, into a sea of opalescent hues. But as the intensity subsides,
we turn our gaze to the north and east. The subtlety of the mauves
and magentas can be more mystical, more heartfelt, than the most brilliant
sunset, the lingering pastel softness serving as a quiet benediction
following a triumphal anthem.

27

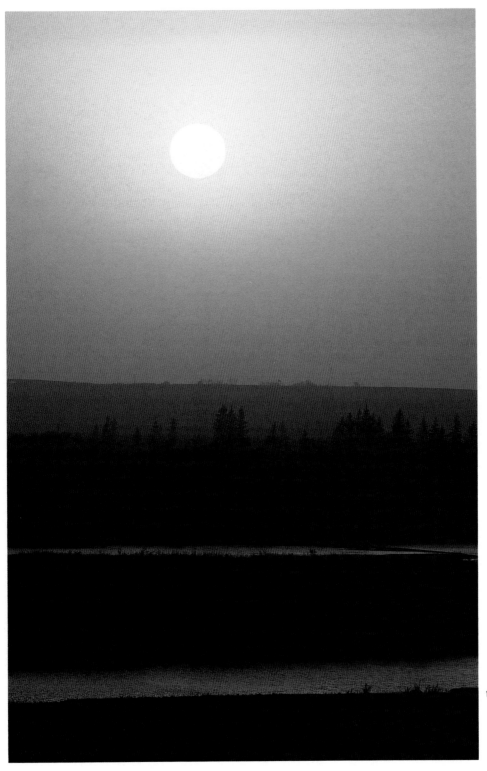

September

Like snow, water also offers mirrors for sky color. It is a special joy for me to park my tripod on the crest of a cliff that rises from the shores of a river and eye the changing fortunes of sky and current. At the close of day the sun, swallowed by the distant haze, will deepen in color within a few seconds. These two images, though not made on the same occasion, speak of the qualities of light as the sun completes its descent.

Autumn Rose

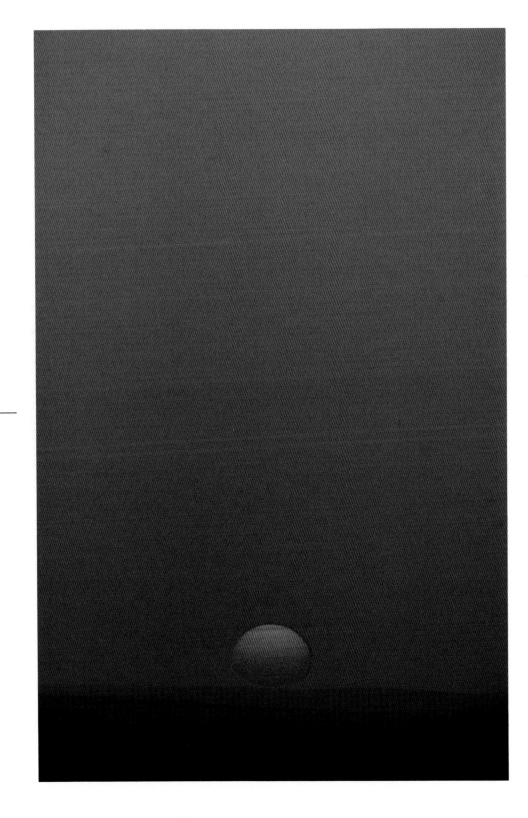

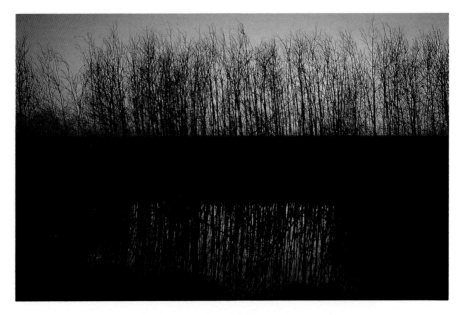

Tree-line Reflection

Unlike the reflections on the preceding pages, the pond here offers
a diversion from the sky tones above. Like the visions seen by a fortuneteller
gazing into a crystal ball, sometimes what is perceived does not reflect
the surrounding reality. Even the tree shapes appear to have been altered
by the alchemical qualities of the lake. A sacred place perhaps, where one can
glimpse, however briefly, beyond the mortal boundary? Whatever
the explanation, one thing we do know: Prairie skies are capable of outrageous
displays of color, reason enough to celebrate our earthly existence.

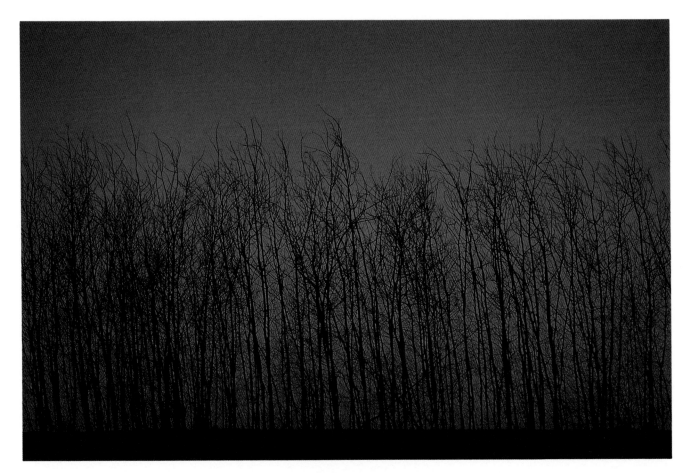

Naked Tree Line

Few prairie pioneers want to be reminded of the Dirty Thirties, when the wind
blew incessantly, carrying the precious topsoil along with it. For weeks on end
the sky remained a murky gray-green, both sun and rain having forsaken
the land. Driving through this storm, I waited for an appropriate foreground
before parking the car. With film loaded and exposure controls preset, I quickly
leaped from the driver's seat, hastily made a series of exposures, then ducked
back into the car for cover, grateful for the protection and my ability to escape.
As I drove away I pondered how the farmers 60 years ago had no such options
as they struggled to make a living from the depleted soil.

Dust to Dust

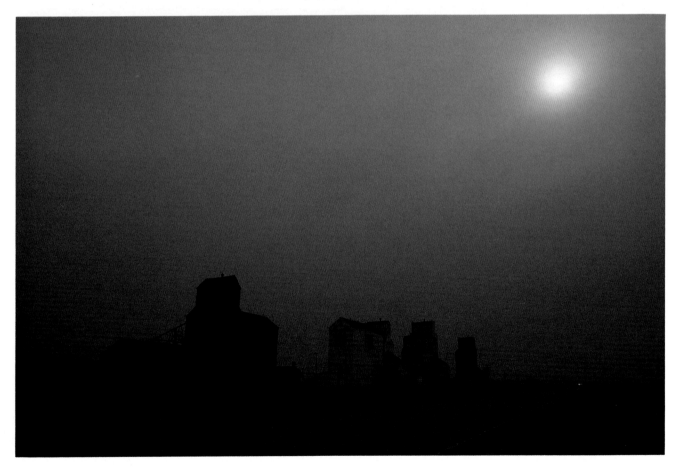

Emergence

Though this elevator is also bathed in the dust of the day's labor, it is a more inviting landscape. Rather than simply striving in vain to break through the haze, the sun emerges victorious, crowning the day's achievements with warmth and cheer.

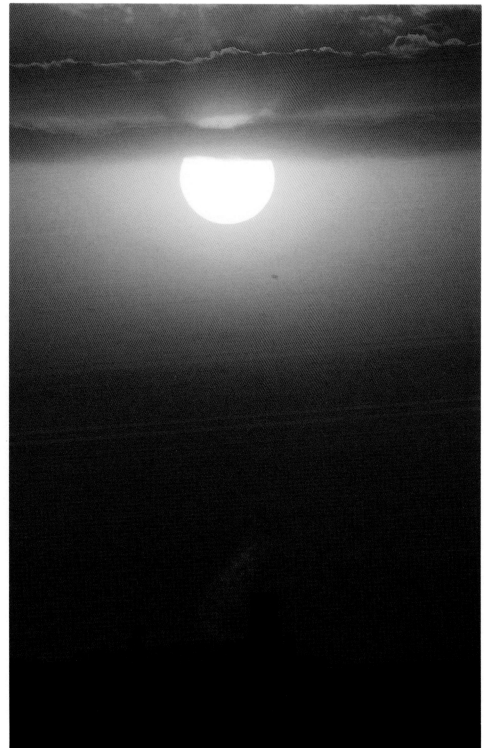

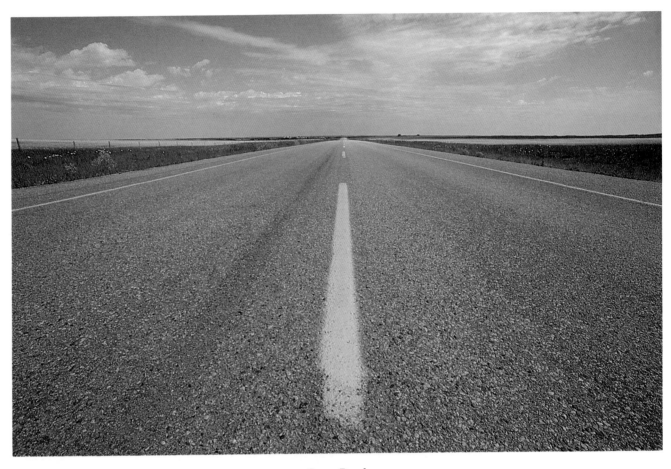

Open Road

Perhaps more than anything else, the Prairies are associated with blue skies
and wide-open spaces. A sunny summer afternoon is an invitation
to hit the open road, feel the breeze, and bask in the glow of light
and warmth. The canola fields (*opposite*), ripening to a rich yellow in July,
provide an additional swatch of color,
a vibrant dance floor to complement the big blue roof.

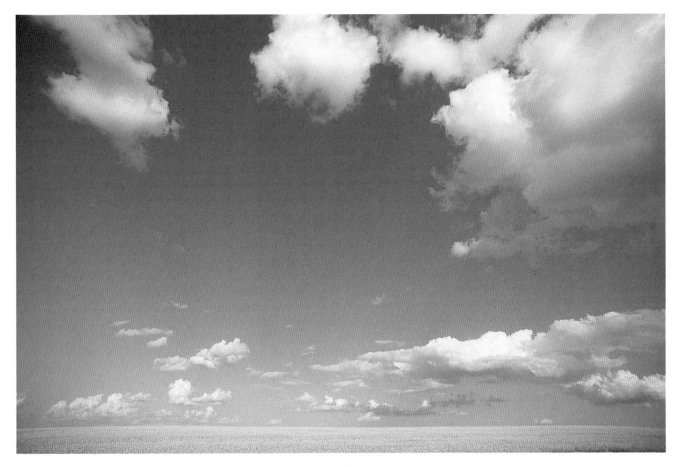

Sky Blue

To record this scene I had to be lightning fast! At night one can leave
the shutter open and wait for several forks of lightning to strike, but during
the day one must see the bolt, react quickly, and pray that the shutter opens
before the flash dies. I once taught the technique to a group of eager amateurs,
all lined up with a colorful fence in the foreground. Each time the lightning
struck, 20 shutters clicked. Out of 400 exposures that afternoon, not one
portrayed lightning. I never taught the technique again!

Wild Weather

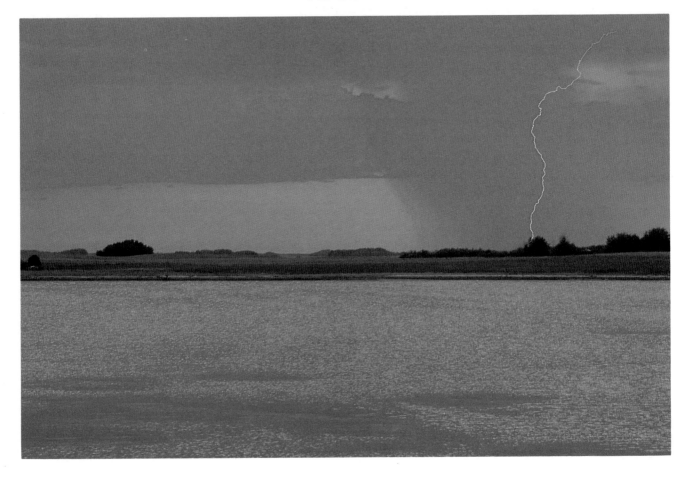

Dawn in June brings morning light onto the wild mustard. Even if it means
cutting into a deep sleep, I will rise to witness the festival of color, then crawl
back into bed as the richness of the light diminishes. I made this exposure
outside my front door at 5:30 A.M. I would sometimes prefer
to rise like civilized folk and work at more regular hours,
but such is the lot of cabbies and shutterbugs.

Wild Mustard

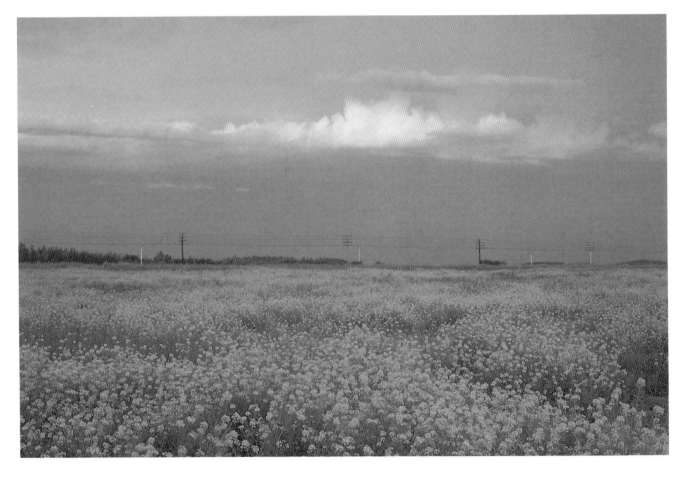

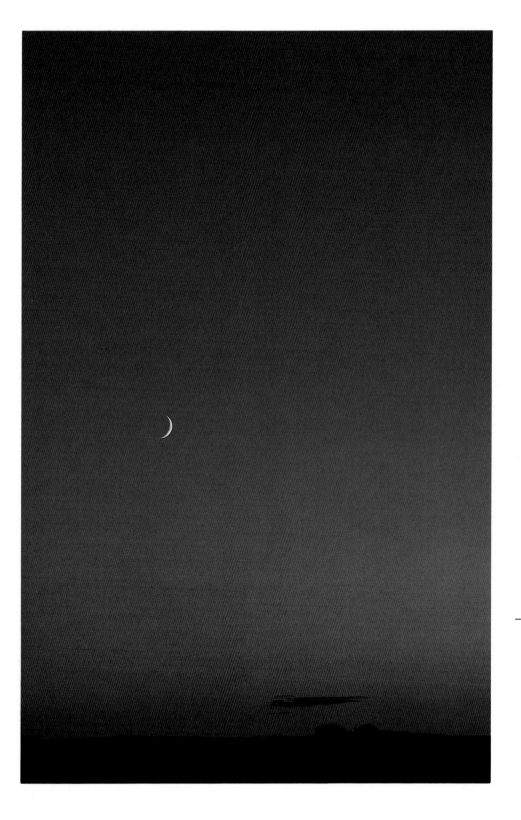

Solitude

Celestial Palette

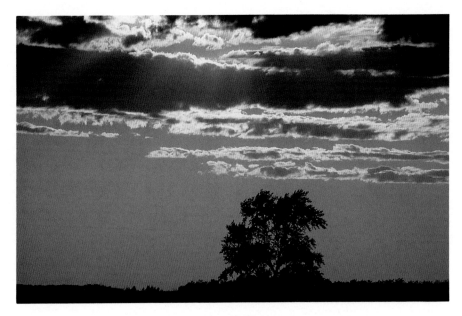

Sky Gold

The sky is so vast on the prairies that at night we sometimes feel surrounded
by uninterrupted and impenetrable darkness. Perhaps this is the reason
that we welcome the moon, especially the full moon. Not only does it light
our way, but because of the flatness of the land and the uncluttered geography,
it remains visible for longer here than over other more varied terrain,
where elements in the landscape may obscure it from view.
Maybe it just likes the prairies better—more room to shine!

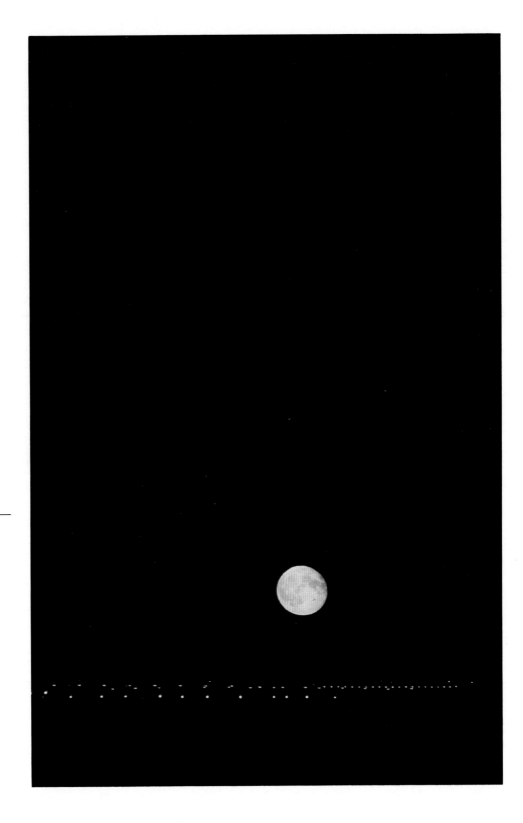

Moonlighting

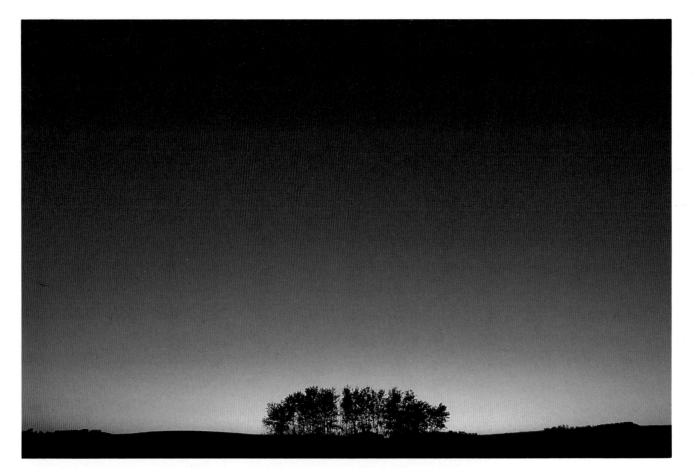

Tranquillity

As a devotee of sky aesthetics, I take great delight in finding a harmonious
mixture of color within a single vignette. Rarely is there a need to add filters.
The atmosphere itself is a giant filter, bending and banding pure sunlight
into the joyous tones that enliven and beautify our daily surroundings.
When the delectable hues tug at my senses, I have only to line up
a suitable foreground.

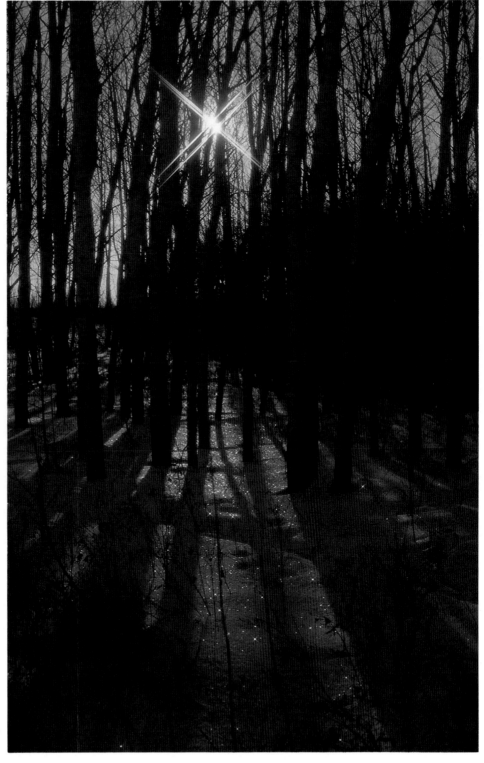

Winter Blues

Winter can be a special delight because the pure white ground cover so ably acts as a mirror for the sky tones. By four in the afternoon, the December sun is already low in the sky, casting long shadows across the moody blue landscape.

Here I added a star filter, perhaps enhancing the feeling of night, or at least the anticipation of a long wintry silence.

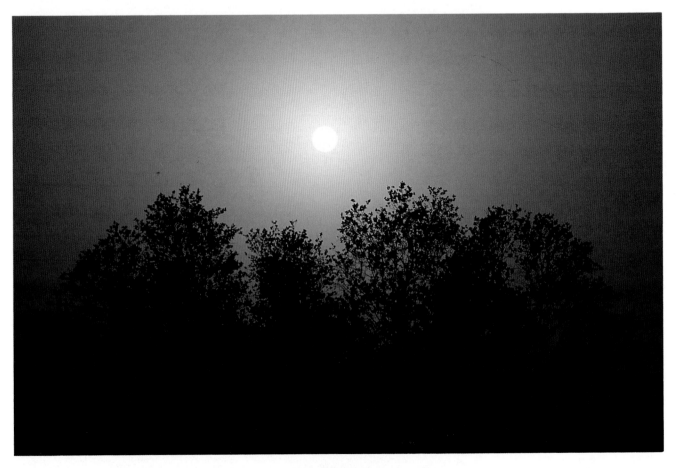

Shrinking Light

Burst of Dawn

Skies sometimes appear more
ethereal, more enticing, when
viewed through the trees.
In order to increase the feeling
of a burst of light, I made a
double exposure of the tree,
once in focus and once out of
focus. The result is the image
of the pine tree bathing in the
warmth of a new dawn.
How often our days start off
golden, yet because we are
cloaked in a cocoon of sleep,
we are unaware of it!

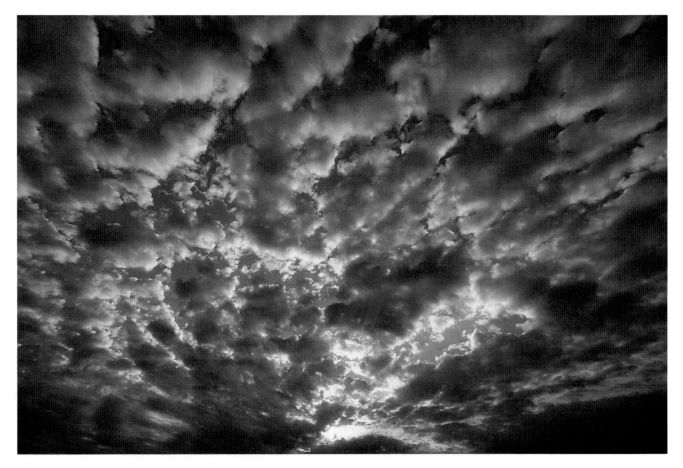

Crescendo

Celebration

I like to describe the prairie skies as an explosion of light and color.
When I see autumn leaves at the height of their glory I have a similar reaction.
To create the symphony of pigments found in *Celebration*, I combined
a close-up of fall leaves with a sunset over a row of grain elevators.
Welcome to my festival of color!

47

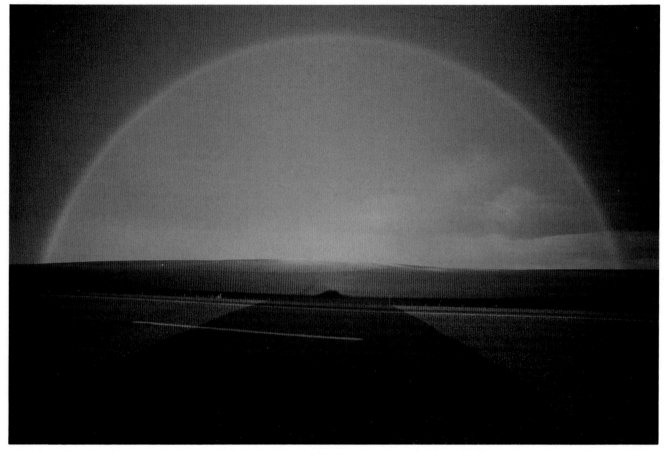

Promise

The Great Roof

Sunset Reflection

The great roof is large enough to house entire rainbows, grand enough
to reach behind the furthest rim, and high enough to encompass the sun,
moon, and stars. Like the corrugated steel Quonsets that accent the farmlands,
prairie skies hold an abundance of wealth, providing nourishment
that sustains the prairie psyche. In this chapter, we will rejoice in the space
the big roof affords us—a place to stand tall and grow,
and the freedom to broaden our horizons.

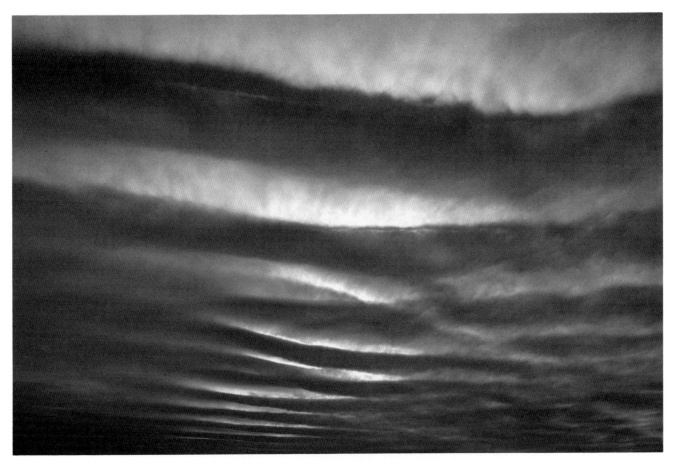

Corrugated Roof

Sometimes the great roof itself is corrugated, forming into ripples—
endless cloud waves that roll across the celestial sphere.
Standing beneath and gazing upward,
one can become lost in the soothing rhythm.

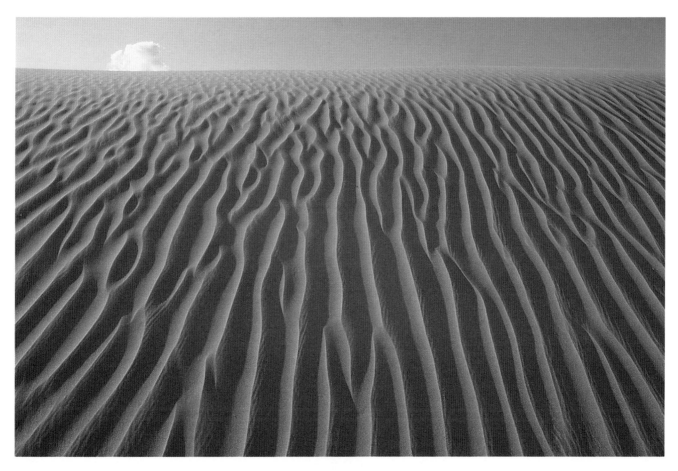

Infinity

When I am alone among rolling sand hills,
I feel as though each rivulet leads on to eternity.
Prairie skies are invitations to reach for the great beyond.

Evening Complements

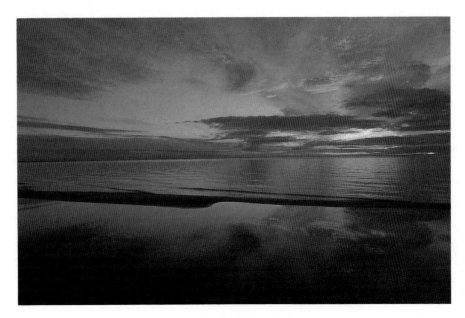

Grand Palace

Sand flats, lakes, and plains have much in common; all are floors
mirroring the many moods of the grand palace. Sometimes tyrannical,
other times gentle and benign, Father Sky is master of the house,
reigning over the elements below, where all are subject to his dominion.

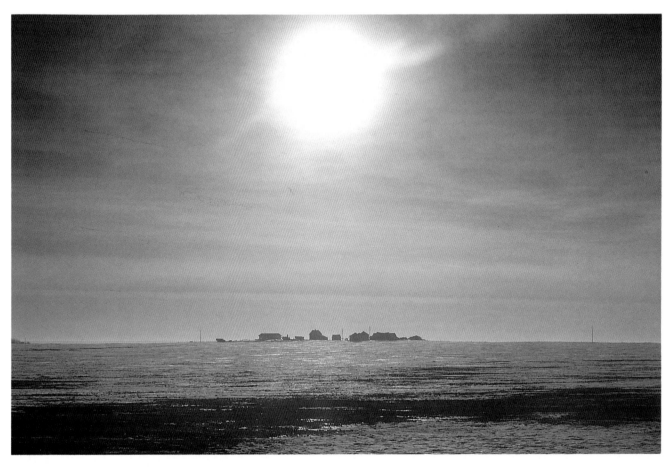

Dwarfed

When I am out on the land, the sky gives me a sense of perspective.
I look up to behold the endless space, then down to acknowledge
the comparatively tiny farms, mere pinpricks on the distant horizon.
But every acreage comes prepackaged with a giant screen
and a continuous sky show, all of it free!

During the autumn the trees add their part to the drama. Sometimes the sky
will fill with a sombre purple-gray cover, all except a sliver of light in the east.
At dawn the rising sun will beam through like a spotlight, highlighting
the fall foliage in its moment of glory. Then suddenly, silently,
the illumination is gone, perhaps returning briefly at sunset
for a last curtain call.

Autumn Purple

I cannot photograph the immensity of prairie sky—I can only allude to it.
One of the best ways of doing this is to give an impression of what it is like
to stand beneath it. To help the cause I sometimes choose a wide-angle lens
and kneel to obtain a low camera angle. It seems an appropriate posture—
bowing before a masterpiece in blue, window to the heavens.

Reaching

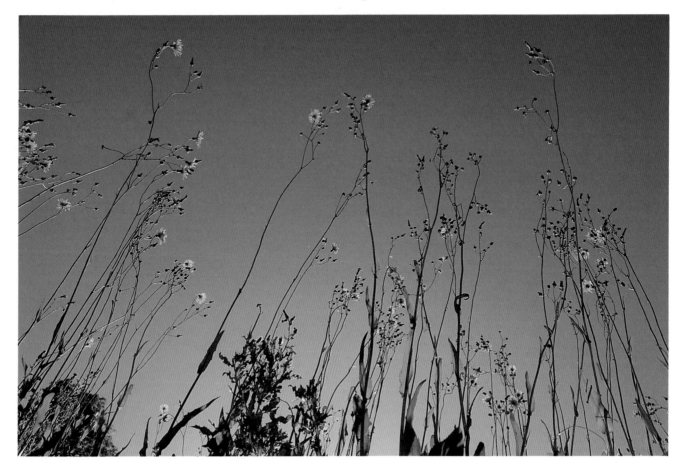

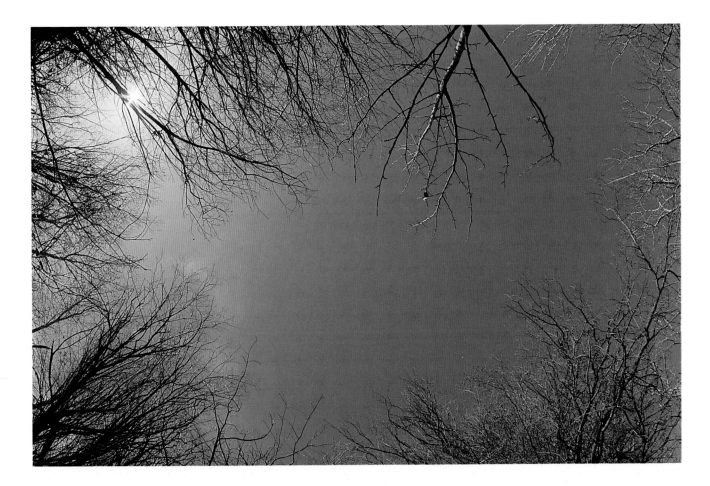

Beyond

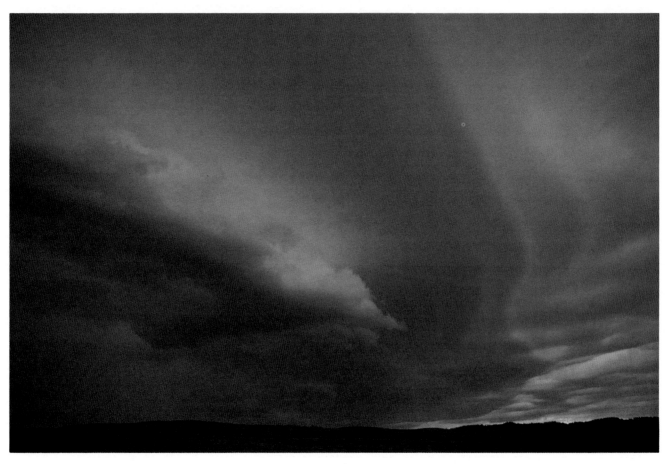

Attack

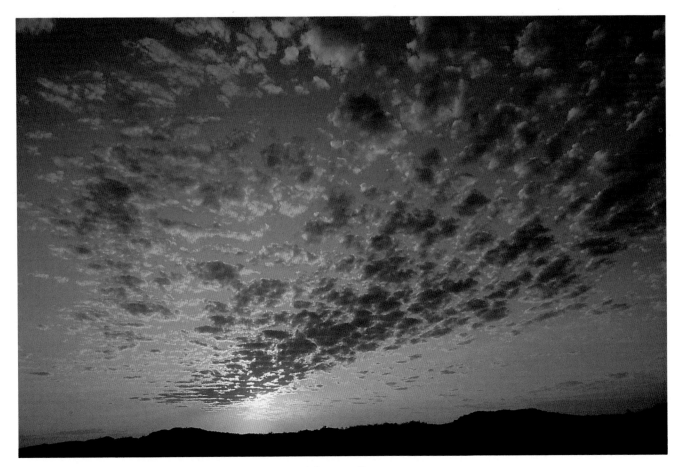

Morning Start

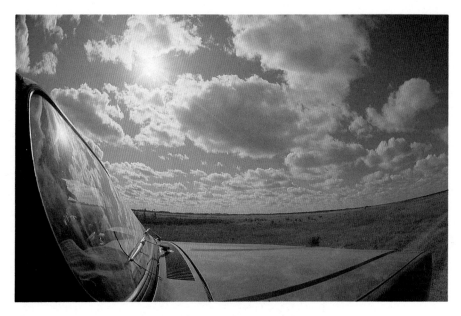

Out on the Range

Ranchers enjoy the sense of freedom engendered by the limitless space
under the big roof, but they also recognize their dependence on the elements.
It is to the sky that they must turn for rain and wind, and during times
of drought the wind becomes their passport to survival, for it is the brisk
northwesterlies that most forcefully turn the blades of windmills (*opposite*)
to draw the water from the ground.

Prairie Wind

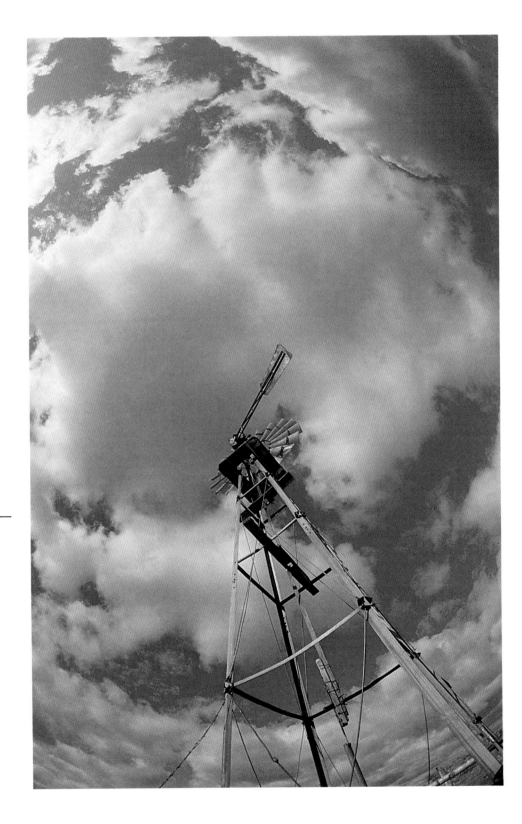

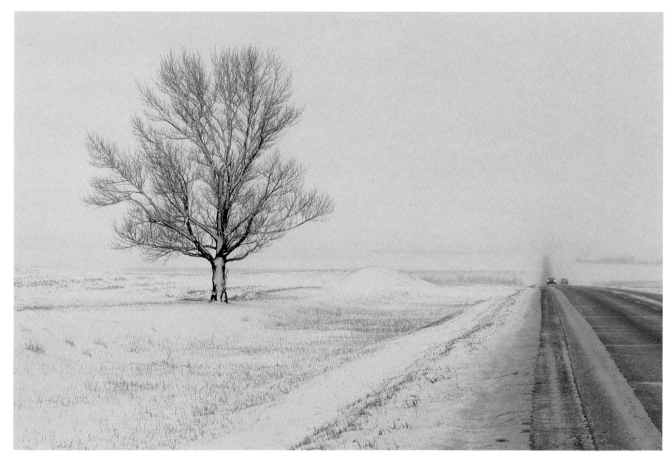

Lone Tree

This lone tree stands beside the highway, five kilometers (three miles)
north of Swift Current in southwest Saskatchewan. Because of its isolation,
it has become a landmark to thousands of folk in the region, and for many
more who visit on occasion. The surrounding landscape is so barren
that locals affectionately refer to the tree as their national forest!

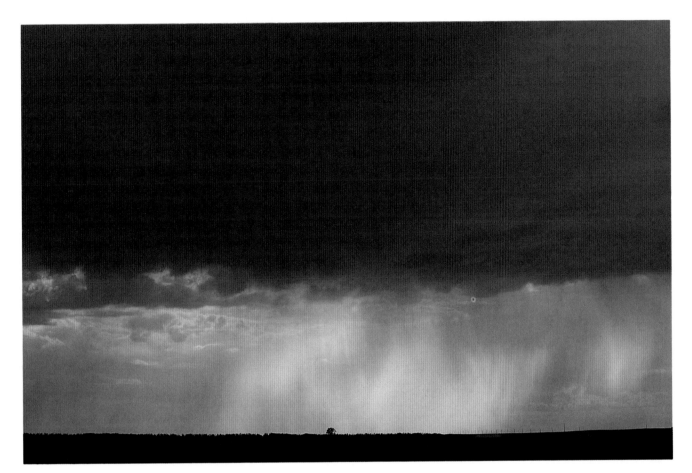

Distant Reign

When you stand under the great roof, you don't question its dominion
over the land. You are a mere speck on the plain, dwarfed by the enormous
firmament above. Photographing such an overpowering sky presents
an almost impossible challenge. One method I have found to hint at its
immensity is to show the world below in proportion. Here a lone tree stands,
barely visible beneath the vastness of a distant storm front.

Orange Sunset

At times the prairie sky feels too huge to confront. There is simply too much
space to deal with. One retreat is to secure a close-up lens to the camera
and play among the grasses. Here, as I focused on a couple of curly wisps,
the setting sun appeared, looking like an orange, ripe for the picking.
Then, changing to an ultra-wide-angle lens, I photographed the same sunset
(*opposite*), once again giving the sky its rightful place in the scheme of things.

The Great Roof

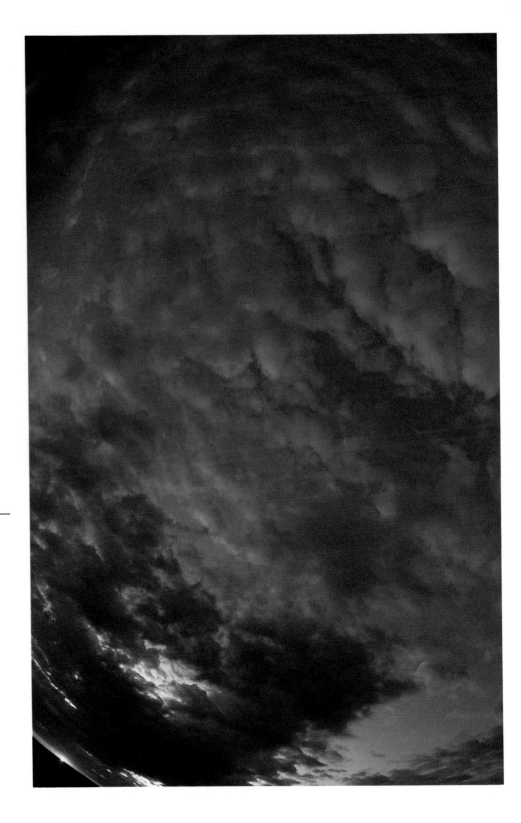

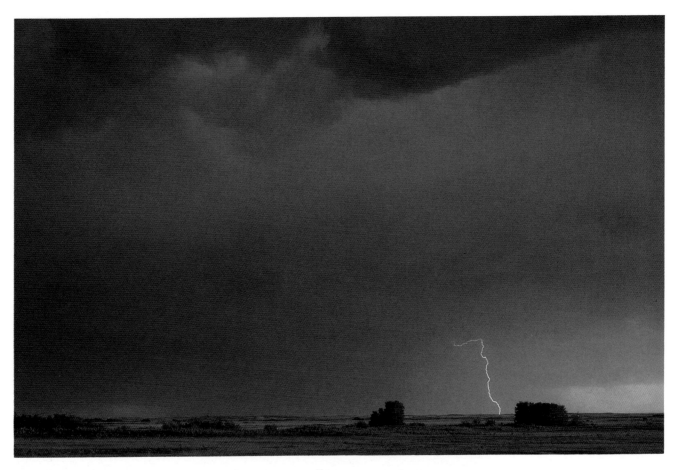

Ignition

Once when I was photographing in a lightning storm from the top
of my camper, an epic drama ignited around me—lightning to the south,
a brilliant rainbow to the east, a colorful sunset to the west,
and ominous stormclouds in the north. I worked feverishly until the light died
and huge drops of rain began to pelt down, then hastily descended
from the roof of the camper, tripod and camera in hand. Seconds later,
a lightning bolt struck the camper with such force I was knocked to my knees.
This photograph is my reminder of sky power
and the importance of exercising caution.

Home

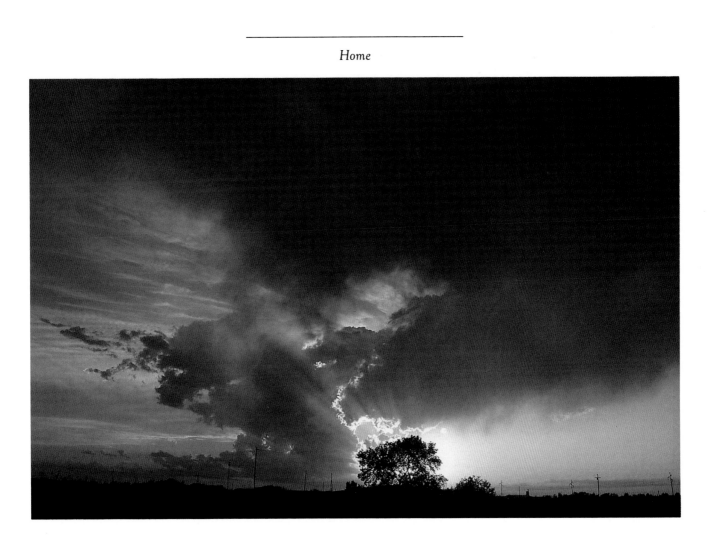

Prairie skies, like the land beneath, have seasons. There are of course the more obvious cues, like snow flurries in winter, or smoke from forest fires in hot weather, or the arrival and departure of certain birds, that characterize particular seasons in the sky. Most of us know, as well, that northern lights are more common in spring and fall, and that the moon appears larger at harvest. But besides these easily recognizable signs, there are many more subtle qualities of color, tone, cloud patterns, and an indefinable feeling in the air.

Summer Song

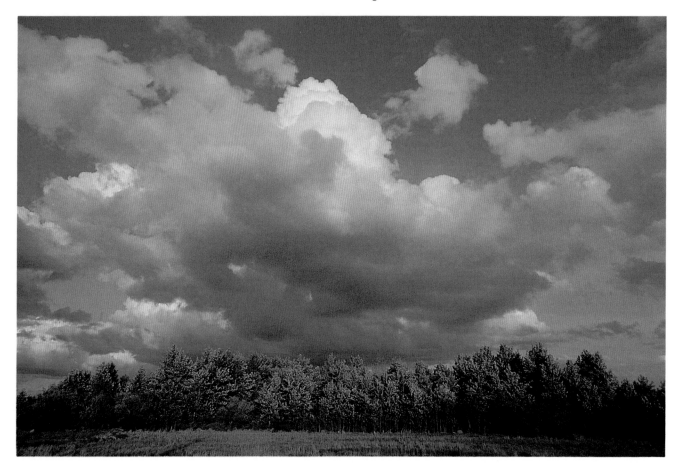

Here are two photographs of the same tree line, first in July (*opposite*),
then in September (*below*). Notice how the sky belongs to its respective season.
Learning to identify the subtle shifts from one season to the next
not only puts us more in tune with the elements, but also enriches
our day-to-day experience of the outdoors.

Autumn Lament

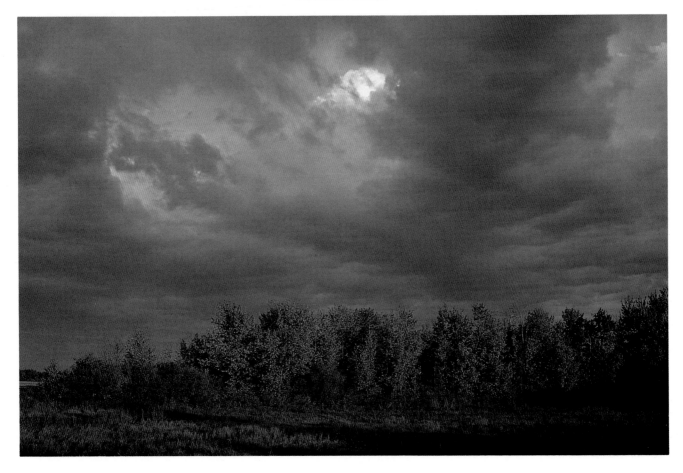

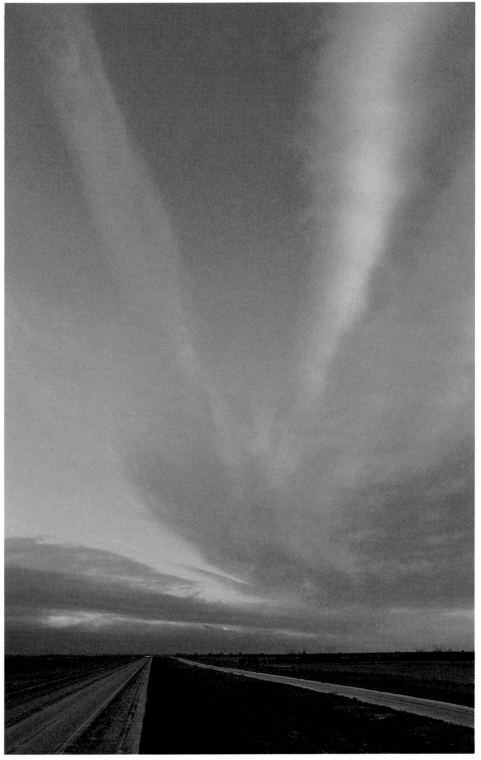

Victory

Sometimes, while sky-
watching, I've seen a band
of clouds break away from
a larger formation, and I
rejoice in the sense of freedom
it evokes. Here the winds have
conspired as well,
pushing the clouds to new
heights, and victory seems to
have been proclaimed!

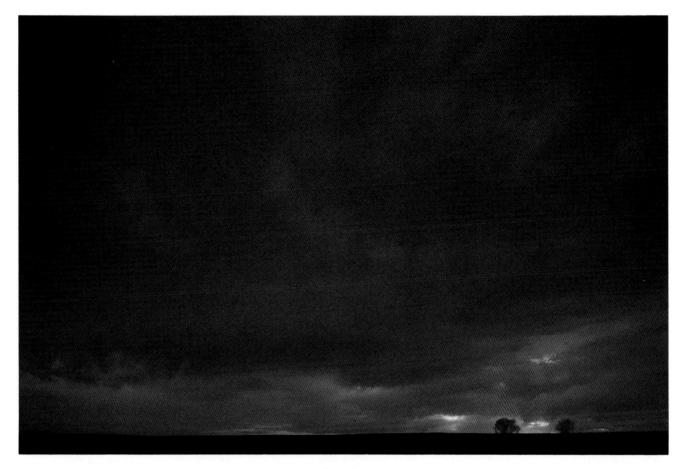

Sacrifice

Early one October I drove for hours to be on hand when thousands of geese
would lift off from a marsh on their southern flyway. I woke early, in time
to record this sunrise, but the geese were still asleep. Then, as I reached
for a new roll of film, a gust of wind whipped my tripod to the ground,
resulting in irreparable damage to the camera. *Sacrifice* is my bitter-sweet
reminder of watching without a camera as the great morning sky
filled with the wings of ten thousand birds.

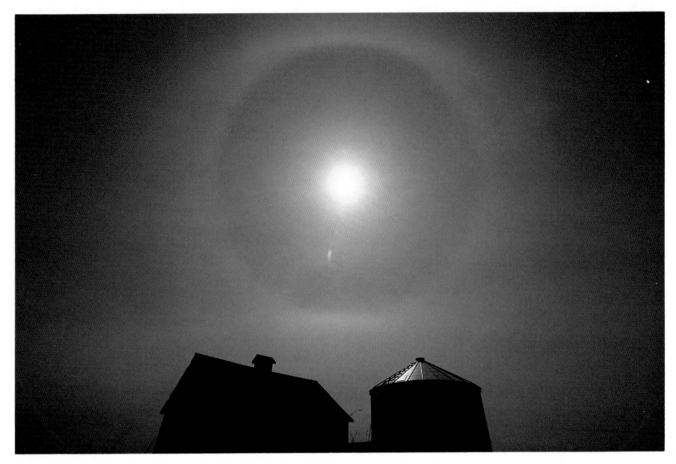

Oracle

Emotion

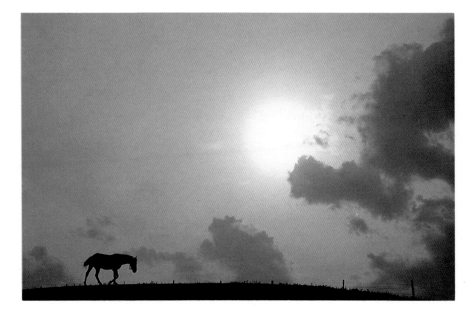

Downcast

We have observed the grand size of the sky, witnessed its incredible array of
hues, and learned about its role as oracle. But prairie skies also evoke emotion.
Their size, texture, color, tone, and changeability deeply affect the psyches
of those who live beneath. Like the old horse plodding along in the above
photograph, we too can feel downcast on a gray day, or, like the stag gazing
at the golden sunrise (page 91), we can stand tall, feeling confidence and hope.
In this chapter we glimpse some of the moods of the heavens
and examine how they affect us mortals below.

Sun Nest

Early morning mists (*opposite*) are not only refreshing but also display
a softness that nourishes the soul. And with the real world
reduced to filmy shadows, a feeling of mystery often pervades the land.
Dawn can be a quiet time, but what appears tranquil on the surface
may disguise deep currents within.

Morning Calm

Treasure

The prairie region is not known for an abundance of rain,
but it can occasionally pour for days—to the glee of farmers
and all who depend on the productivity of the land. When I found this leaf
glimmering with drops after a heavy rain, I felt it was the perfect symbol
of the value of water. As precious as diamonds, I thought,
as I peered through my macro lens and two extension tubes
to get a close-up view.

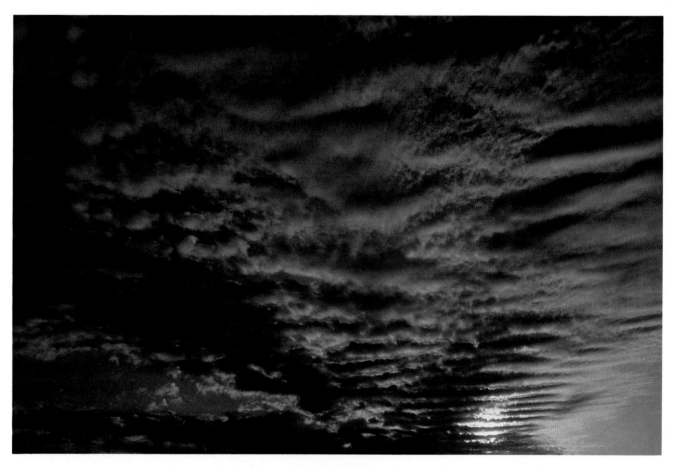

Skyward March

Precious, too, is the time after the rain. The sun emerges
and the clouds seem to wrinkle and then bunch, as if preparing to regroup
and march off to a new location.

Sometimes the sunset light evokes a feeling of melancholy,
as if the sky were in deep anguish or pain.

Anguish

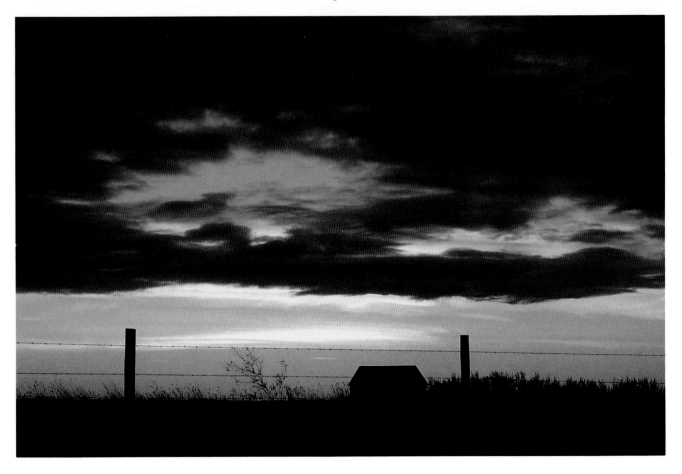

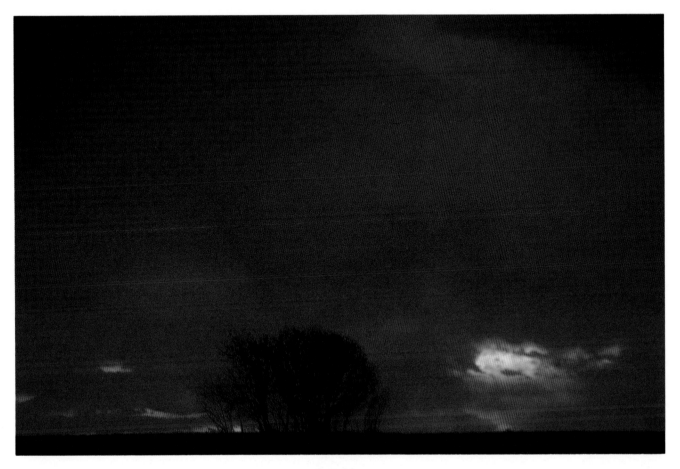

Red Alert

Occasionally a dawn sky will turn blood red. Is it pain,
or is it the red of passion, lust, or violence?
Perhaps our perception of the intensity is a mirror of our inner selves,
rather than a reflection of nature's mood.

Purity

White stands for purity, blue for loyalty. In winter, a mantle of snow
dressed in sunlight is the ultimate complement to a cloudless sky.
The crispness of the air and the clear open space
give us prairie sky at its finest hour.

Waiting

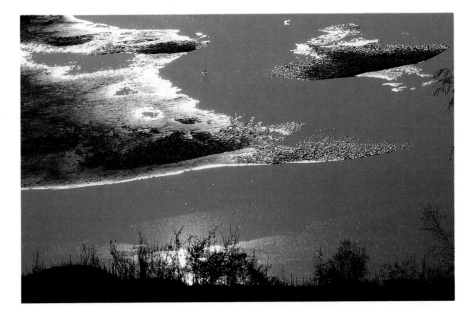

Windswept

Sometimes when I stand overlooking a river and gaze down at the sandbars,
I think I see a windswept sky. Not only is the sky reflected in the water, I muse,
but through the cycles of nature over eons of time the river itself
has been in the sky, in the form of cloud, snow, rain, and mist.

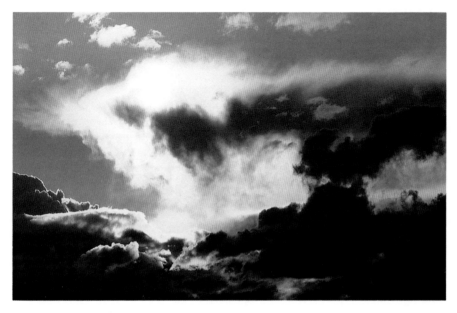

Tempest

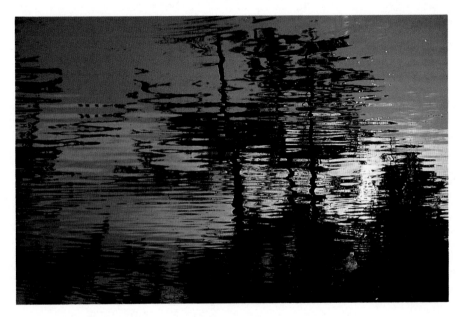

Watercolor

I love to peer into water and photograph the reflected sky
complete with a new texture. When I turn the resulting image upside down,
it looks more like a painterly canvas than a reflection.

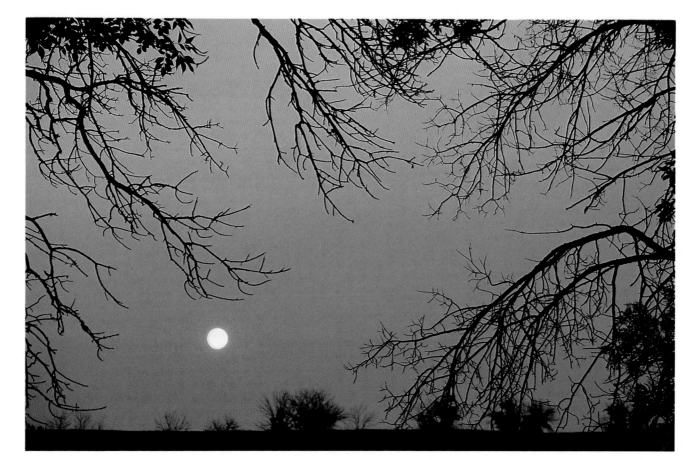

Prelude

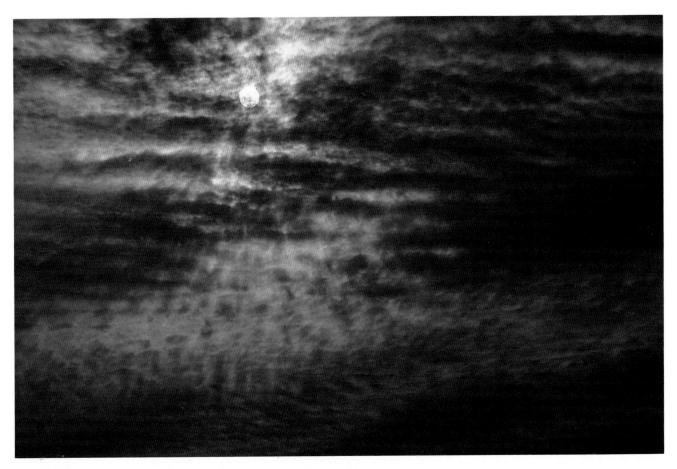

Foreboding

Night on the Great Plains has its own ambience, its own moods,
and creates its own rhythms. There is a magical feeling in the air at the time
of the full moon and a sense of mystery, even foreboding,
when the moon is masked by a veil of cloud.

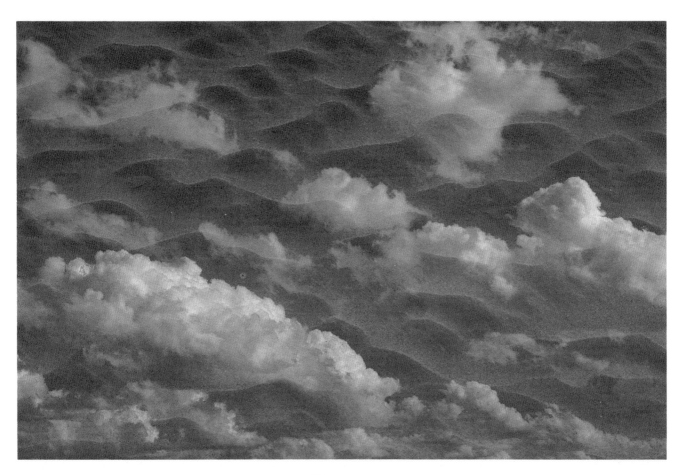

Dreamswept

The use of water reflection is not the only technique by which a photographer
can enhance the texture of the sky. When I wander through sand hills
I sometimes experience a feeling of timelessness, a brief glimpse of eternity.
Once, unable to decide whether it was the sky or the sand
that contributed most to the mystical feeling, I pointed my camera
at each in turn and made this double exposure.

The prairie is known for its extremes of heat and cold. My image
of this tumbleweed was made on one of the hottest days of the year,
when the air reached almost unbearable temperatures. I included the sun
and its lens flare in the frame to further heighten the scorching effect.

Parched

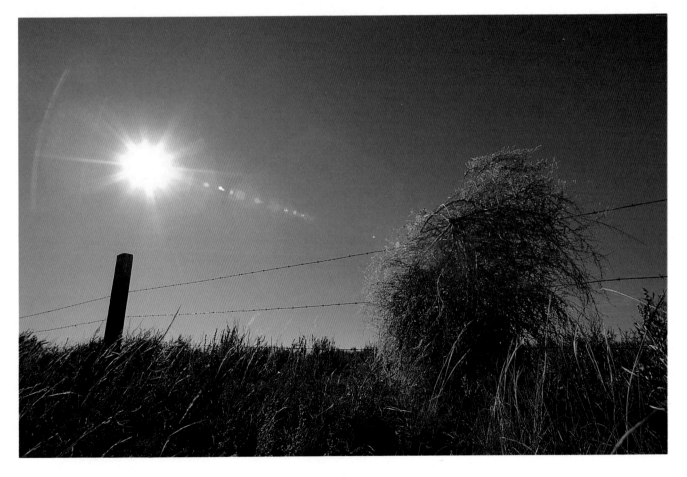

One day when the temperature dipped to -30°C (-22°F), I walked across
an enormous field, aware of the crispy carpet that surrounded me,
but unable to find an image that would portray the frostiness of the place.
Impulsively, I leaned forward, dipped my lens in the snowbank,
and pointed the camera at the late afternoon sun. Voilà! Instant shivers!

Frozen in Time

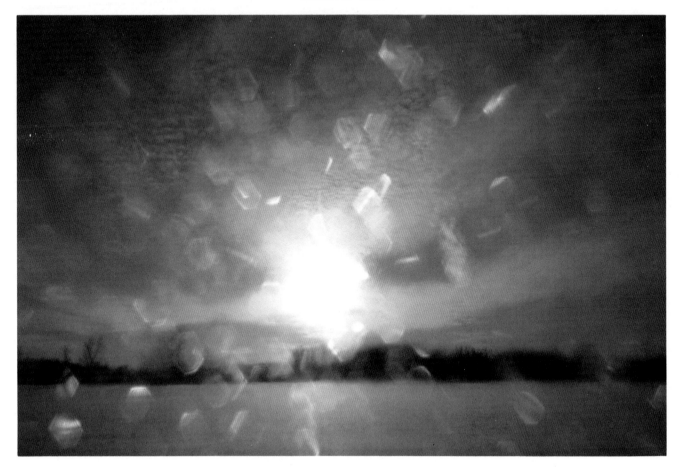

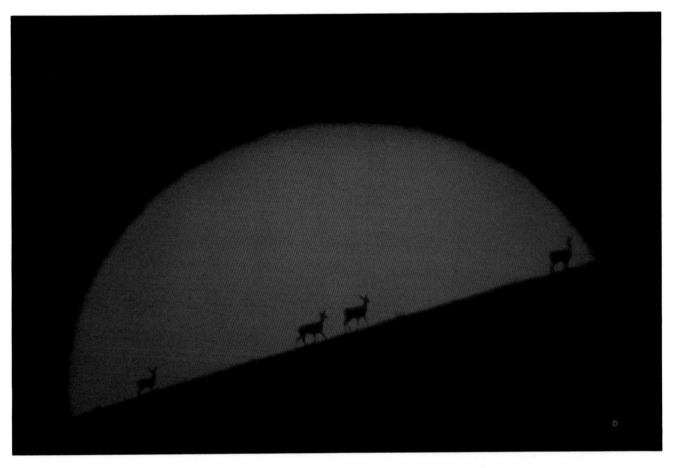

Ascent

I swear that the setting sun looms larger on the prairie than anywhere else.
We do, in fact, see the sun at the horizon through a great deal of atmosphere,
which makes it appear even larger. I photographed this sunset
with a 3000mm lens, and though it was more than 150 million kilometers
(93 million miles) away, it looked as if the sun was sinking
just behind yonder hill.

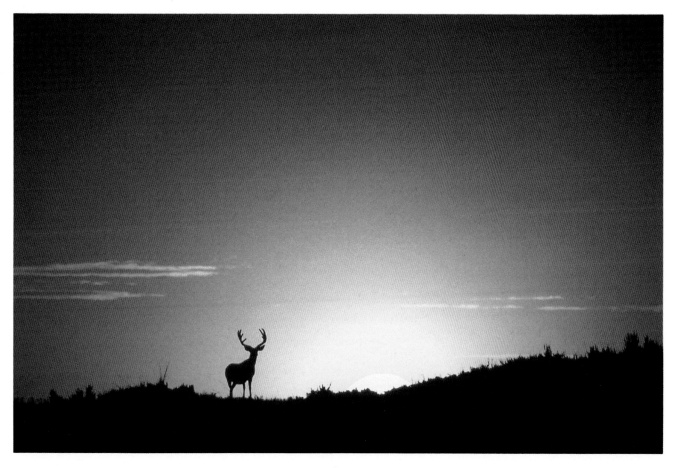

Awakening

I like to believe that when shown a photograph, I can discriminate
between a sunrise and a sunset. For me this skyscape epitomizes the warmth,
brilliance, and dramatic power embodied in the sunrise of my dreams.
The appearance of the first sliver of sun is a magic moment
heralding the dawn of a new day.

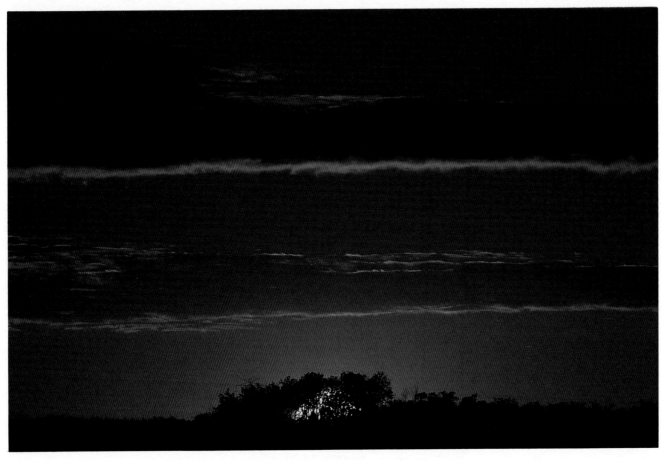

Nostalgia

Drifting

Dusk

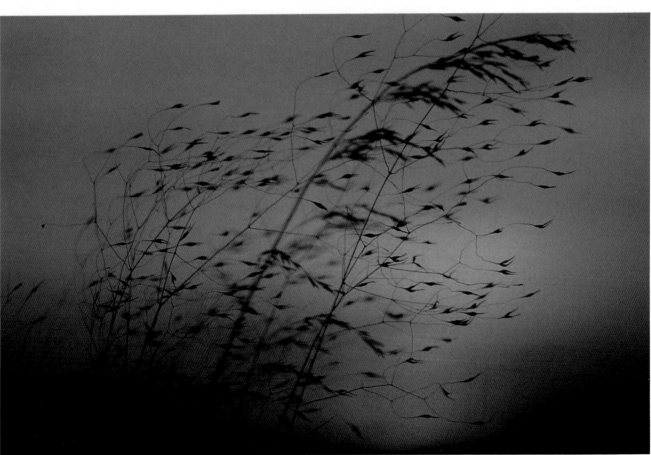

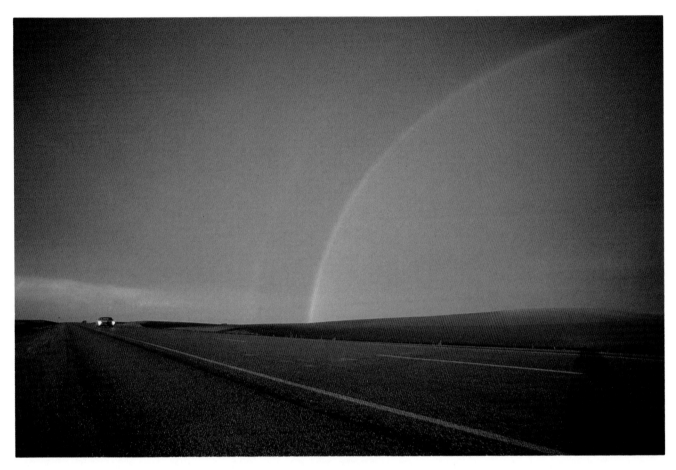

Life's Highway

Rainbows hold great mythic power in many cultures around the world,
and the vast expanse of sky makes them particularly dramatic when they appear
on the prairie. The day I found this double rainbow, all my lenses were in
for cleaning except a telephoto zoom and my 17mm ultra-wide-angle.
The zoom was virtually useless, and I found it impossible to photograph the arc
without including my own shadow. As a car approached in the distance
I suddenly saw the familiar metaphor unfolding: life's highway
with hope ahead, but also a shadow lurking on the periphery.
Even more intriguing was the uncertainty as to whether the rainbow
still lay ahead or had already been left behind.

Last Light

Spirit

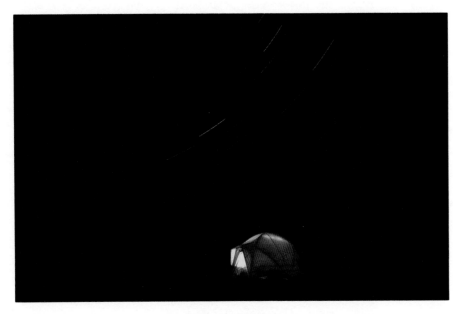

Beneath the Stars

Because the sky plays such a dominant role in the lives of prairie people,
its spiritual component affects us profoundly. Often what we think of
as the spirit of the land is actually sky spirit, beckoning us to look up and out,
to pay heed to the grand scheme of things. Here my tent, lit by a single candle,
sits under the stars. Cloudless night skies provide the ideal backdrop
for releasing the purely personal and strengthening one's connection
with the universe.

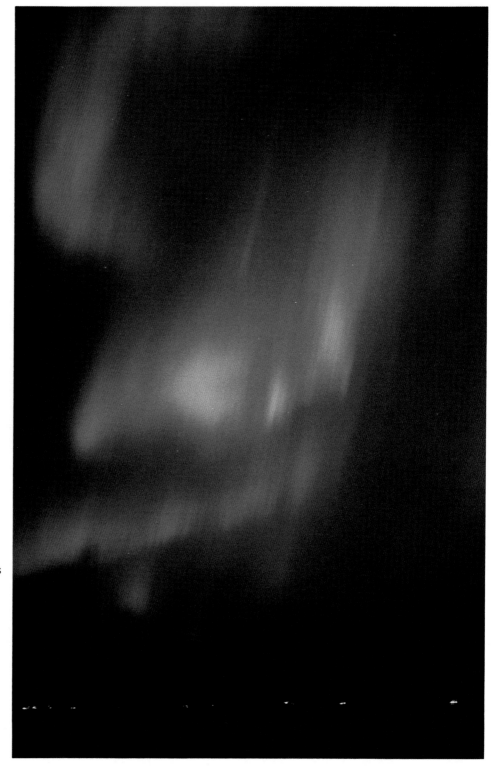

Dance of the Lights

Another mystical feature
of the night sky is the aurora
borealis, more commonly
called the northern lights.
Usually in the northern sky
or directly overhead, the lights
are most frequently seen
in spring or fall, but can be
spectacular in any season.
First a mere glimmer, then
an unmistakable presence,
soon they are dancing across
the sky, captivating
an appreciative audience
below.

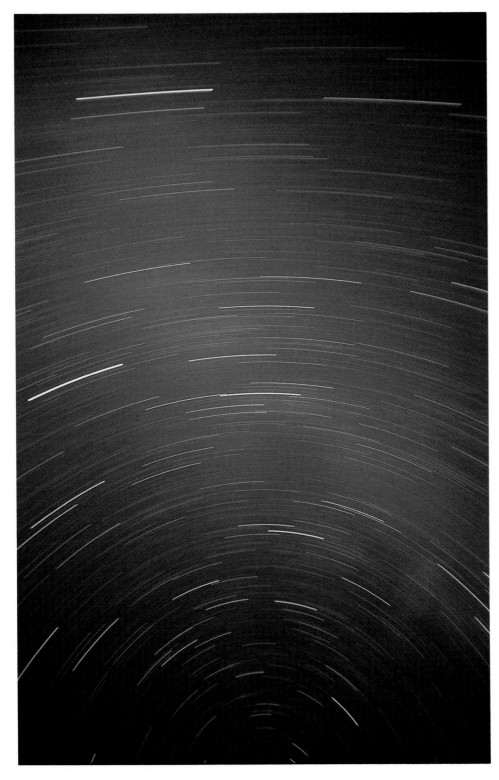

Cosmos

One does not need to wait
for the northern lights
to connect with the mysteries
of the night. To gaze into
the blackness studded with
a million jewels does indeed
put our earthly concerns into
perspective. I made this
photograph with a wide-angle
lens, keeping the shutter open
for more than an hour.

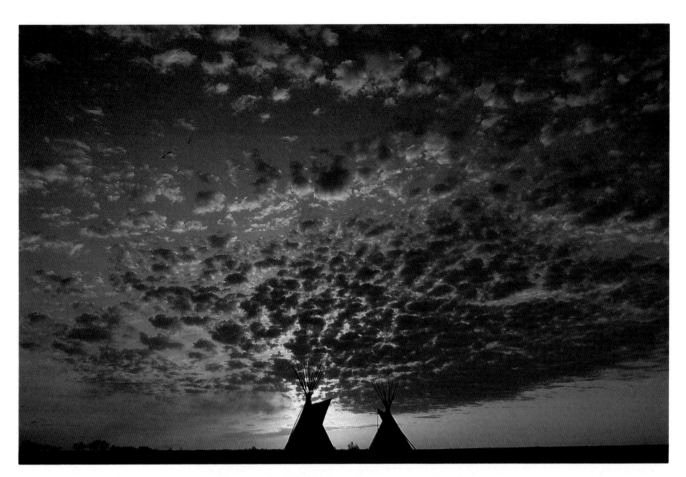

Rainmaker

The Plains Indians in times past paid much attention to the sky;
their very existence depended on living in harmony with nature and the cycle
of the seasons. Their reverence for the sky is reflected in their stories
and legends, which included, among others, the figures Father Sky,
Thunder Man, Rainmaker, and Grandmother Moon. The sky provided
their lives with meaning and direction on a daily basis, offering a tangible link
with what they perceived as the eternal.

Even the great Sioux spirit Wakan Tanka was said to manifest himself
in the clouds. In one story, a red sky was a sign from him that the next day
would be propitious for hunting. The hunter heeded this guidance, depending
upon the direction of the Great Spirit for a successful hunt.

Prophecy

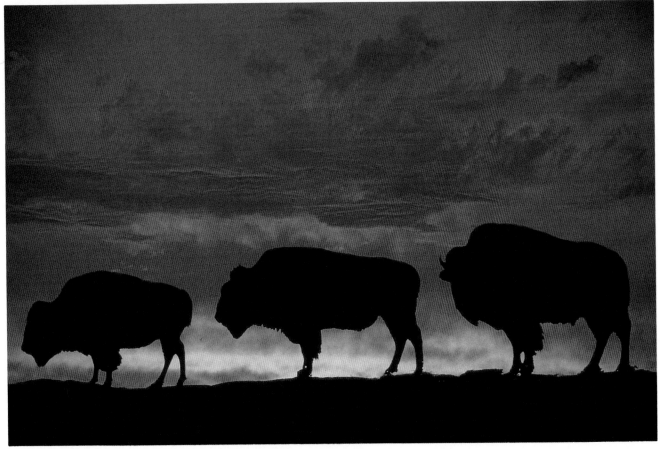

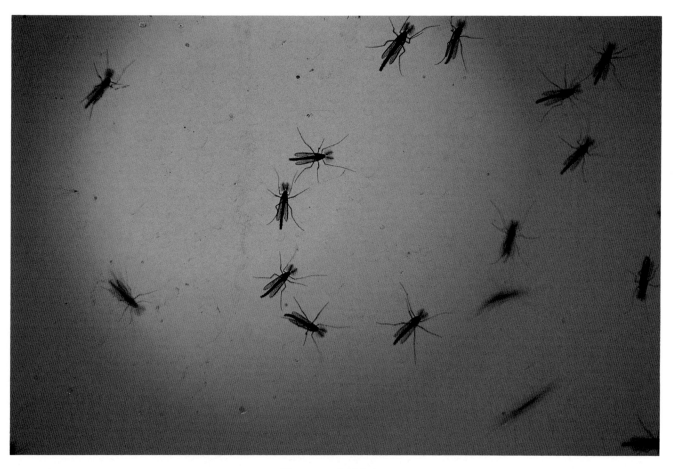

Dance to the Moon

The Indians of the prairie kept track of time with a lunar calendar.
How natural and harmonious this feels, that the month should begin and end
with the full moon, a regular cosmological event when the sun, moon,
and earth align, when energies are reputed to run high and spirits soar.

One evening as the full moon rose into a purpled sky, I watched
some mosquitoes on a window pane. Even they seemed to enact
a celebrative dance as the moon came into view.

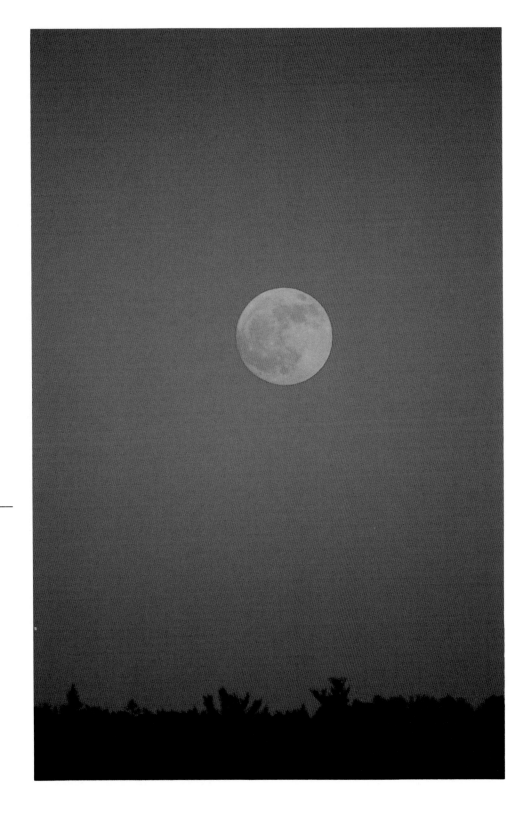

Full Circle

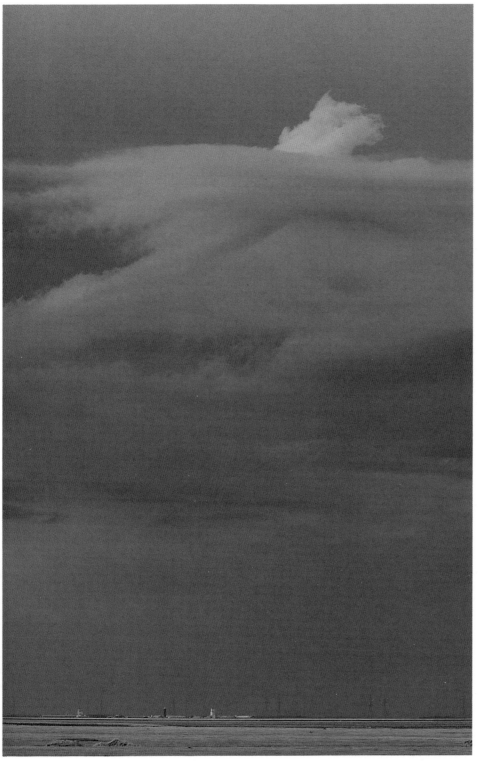

Spirit of the Eagle

How dwarfed are these grain elevators, the tallest landmarks in a prairie town, in comparison with the infinite space above. Sometimes configurations in the clouds, such as the eagle shape hovering in this image, feel to me like guardian spirits soaring protectively overhead. But their massive size and apparent power remind us that our lives on earth are relatively minute when eyed from the lofty heavens.

104

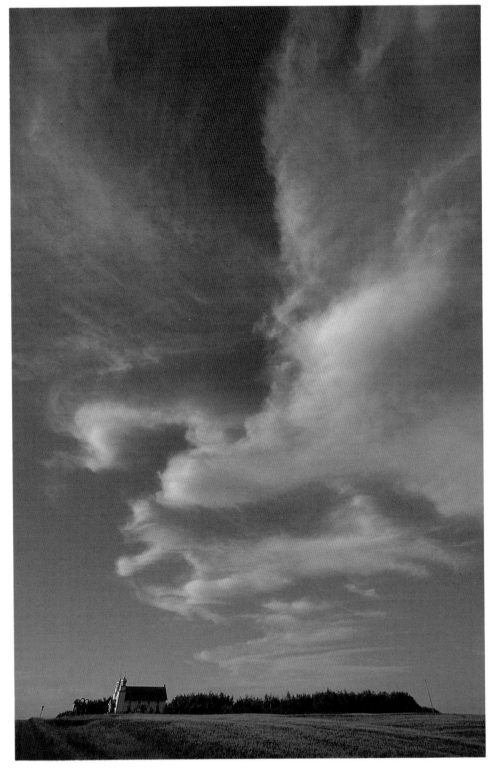

Above

The sky also provides
a reminder that our religious
edifices are not objects
of worship themselves, but
rather are built in praise
of the creator. Regardless of
culture, religion, or theology,
many of our most hallowed
buildings point to the sky
as the source of divinity.
Spires, steeples, minarets,
and domes all reach
to the heavens, a material
and spiritual link
to the great beyond.

105

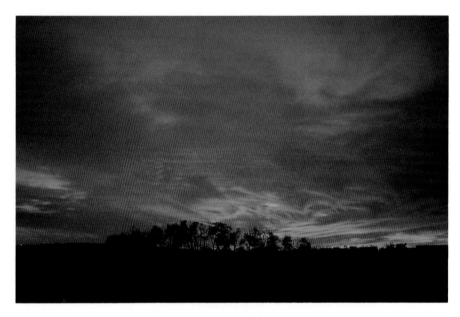

Kistikan Sunset

Fire is spirit, said the priests of ancient alchemy, and it was certainly
a spirited sky that I encountered one night in a park near my home.
The clouds writhed in a turmoil of flame, more like an enormous forest fire
than a sunset. You shouldn't be so surprised, murmured an inner voice,
prairie skies are capable of any spectacle they choose.

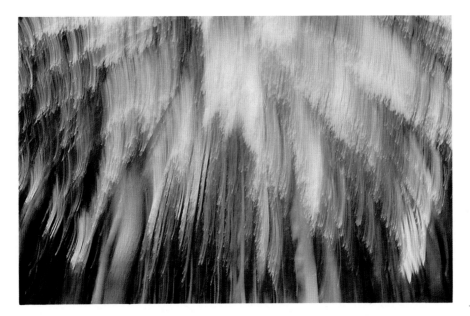

Prairie Palms

Sometimes on the prairie, one needs to hunt for beauty and drama,
and other times to create them, if only in the mind. The day I made this image,
the poplars were bathed in evening light and the sky was a radiant blue.
Impulsively, I grabbed my fisheye lens and made a vertical sweep of land
and sky. The result—*Prairie Palms*, a homemade oasis
in which to commune with the spirits.

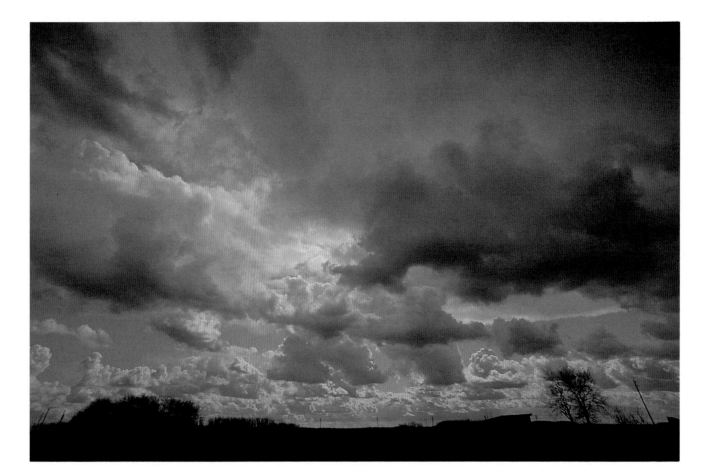

Brooding

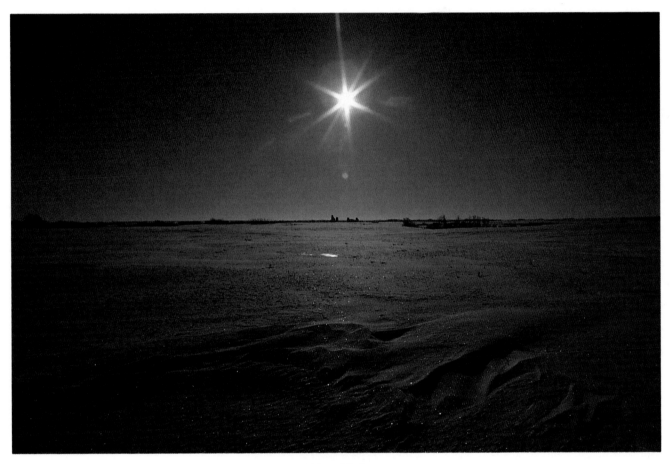

Silent Night

I made *Silent Night* on a snowy field outside a small prairie town
on Christmas Eve. I imagined the town skyline as Bethlehem, the snow
patterns as the sands of ancient Judea, and the sun as the star that guided
the Magi. As I underexposed the image to look like night, I was struck
by the fact that the prairie landscape could so easily support this Christian story.

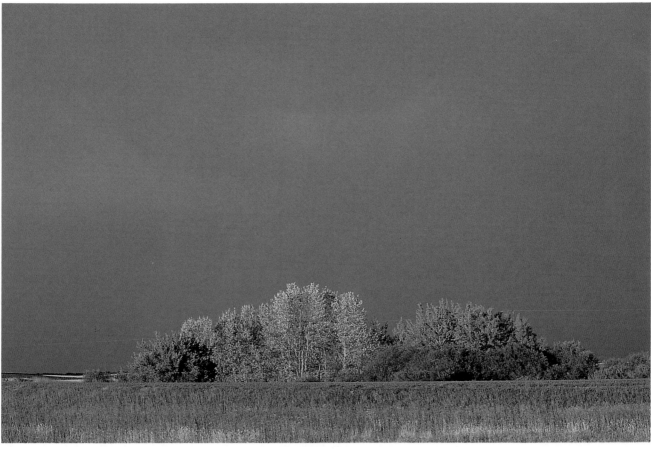

Peace

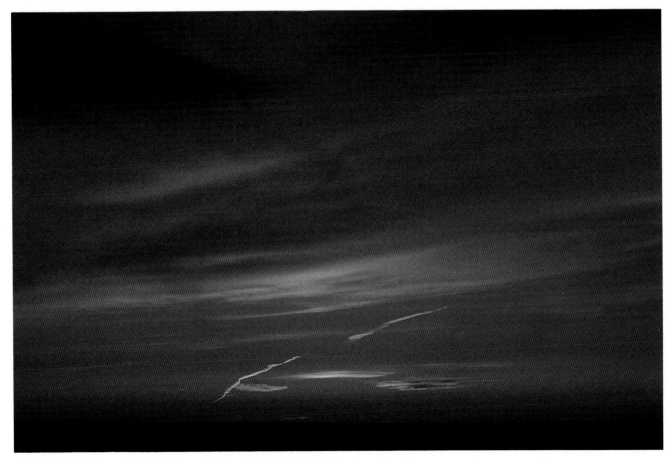

Prosperity

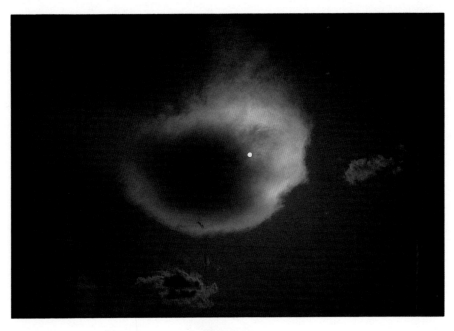

Sky Fish

Perhaps the sky is an enormous psychedelic sea and we live on the bottom.
Could that be a giant puffer fish up there, eyeing its next delectable tidbit?
Never take the prairie skies for granted!

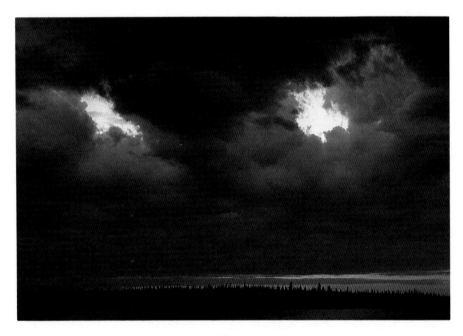

Anger

If there are evil spirits lurking above, surely I caught one on film!
I had risen early and at first light noticed his mouth set in a grimace,
like a jack-o'-lantern's. He didn't seem that angry until I set up my camera
and pointed it in his direction. As I was about to release the shutter,
his eyes suddenly drew into an evil glare and he cursed
in a loud clap of thunder.
I clicked off a few frames, then ran for cover.

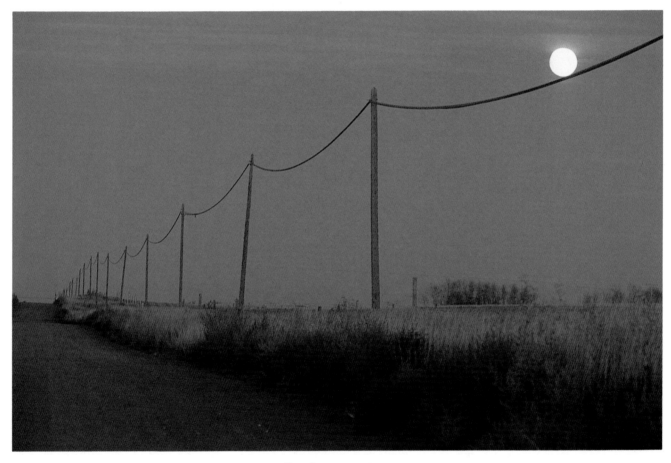

Post-Impressionism

I have long been aware of earthly visits by the moon, but only recently have I realized how playful she is. I have seen her rolling from one post to the next, and when her figure is more trim, swinging from the highest hydro poles (*opposite*). And all the time she acts as if there is no gravity in the situation. Now that's lunacy!

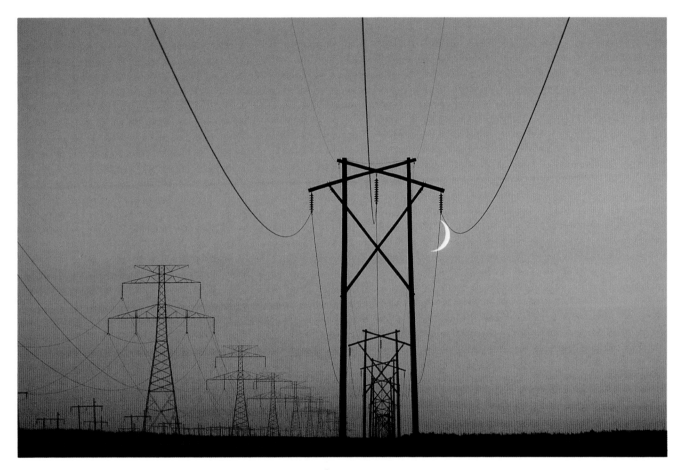

Lunacy

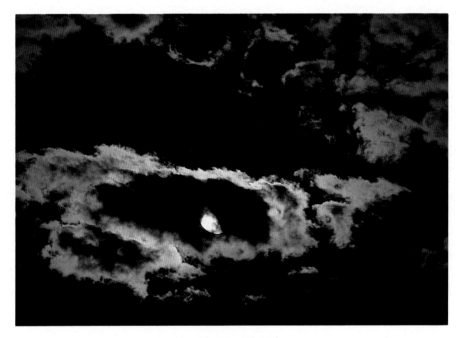

Silver Lining

The moon is not always outgoing and frivolous. On a cold winter night
she retreats high in the sky, sliding from behind one silver-lined cloud
to the next. Occasionally, like the fairy princess of our dreams,
she will peek briefly through a window in a cloud,
perhaps to see who on earth might be watching her.

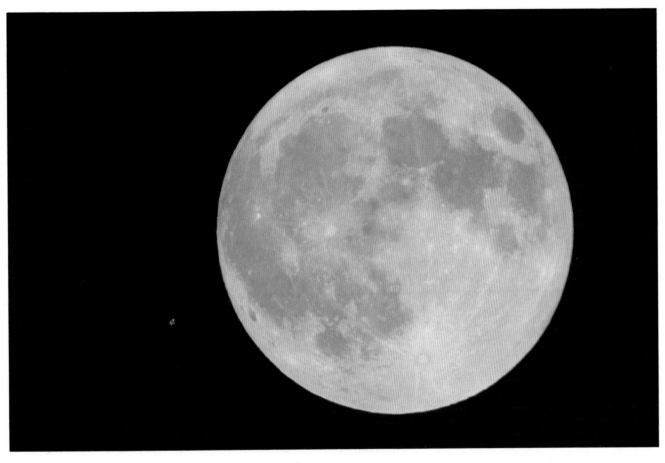

Moon Goddess

The moon is at her finest posing for an official portrait,
sunlight illuminating her splendid beauty. She reigns supreme,
queen of the night sky and priestess of the spirit world. For those who endure
the long dark winters on the prairies, she is a welcome visitor,
bringing brightness and cheer to an icy world.

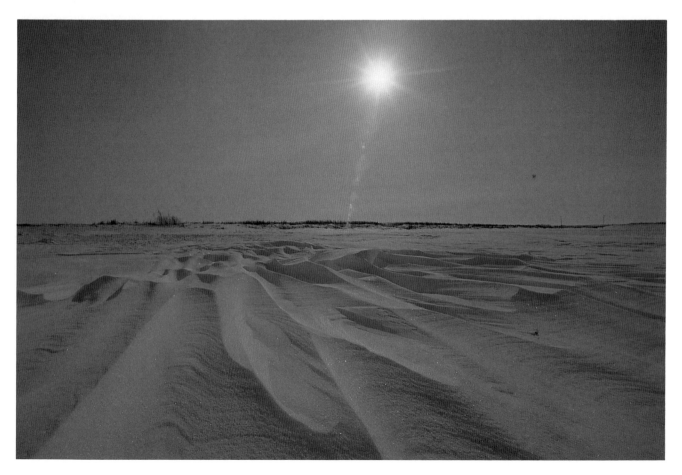

Eternity

One is never quite sure with prairie skies what is fantasy and what is real.
Eternity was photographed on a sunny winter afternoon, but it could
just as easily have been at night—a photograph of the moon
beaming her sacred light upon the land. That is the magic of prairie skies. They
transport you where you want to go, introduce you to a galaxy
of adventures, and return you home renewed, all with a touch of light.

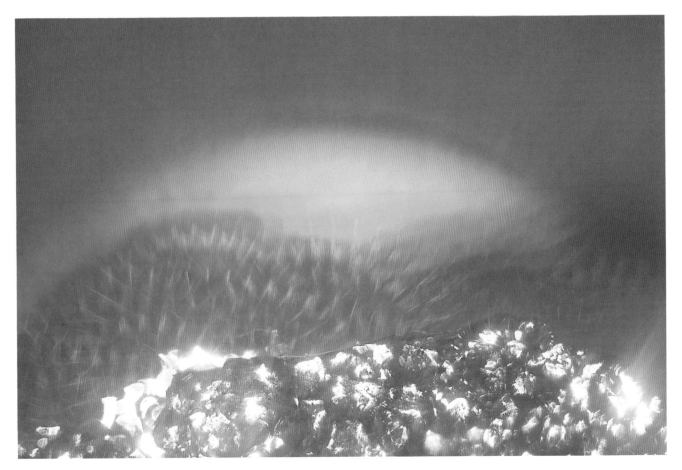

Mystery